Sunshine at Midnight

Sunshine at Midnight

Memories of Picasso and Cocteau

Geneviève Laporte

translated and with annotations by
Douglas Cooper

Weidenfeld and Nicolson
London

© Librairie Plon 1973

Published in France under the title *Si tard le soir*

English translation © 1975
Douglas Cooper and
Weidenfeld and Nicolson
11 St John's Hill London SW11

ISBN 0 297 76904 9

Printed in Great Britain by
Cox & Wyman Ltd
London, Fakenham and Reading

A Pablo Picasso

Il faudrait pouvoir tout dire
la douceur de ta tendresse
sans cesse recommencée
et tes yeux
que soudain allume
la cartouche de la passion
 la colère
ou que miroirs de vérité
au soleil de la connaissance
ils flambent

Tout dire
les plis las qui semblent arracher
à ton regard ses larmes
pour doucement les conduire
à la bouche d'ombre qui les dévore

Dire
ta jeunesse explosant
au toucher de l'univers
et ta main d'huile fine
meurtrière des habitudes
qui parfois retient dans les gants de l'amour
les griffes déchirantes enivrées de visages
 d'âmes
 de femmes

Il faudrait dire
les étincelantes prunelles de tes muscles tendus
les pirouettes angoissantes de ton esprit funambule
toi mon ami toi que j'aime

avec tes haines ta misère
et ta rage fascinant l'absurde
toi qui m'a tout appris tout donné
jusqu'à tes ailes de feu pour encercler la terre

Il faudrait . . .
mais les mots se vident qui t'approchent
muets d'un monde écrasé qu'ils ne peuvent ouvrir

Geneviève Laporte
Saint Tropez, 12 July 1951

Illustrations

Introduction

Geneviève Laporte filled for a while an important though shadowy role in the private life of Picasso. Yet very few of his friends met her or knew much about her personally. Now she has sought out the confessional. Both Geneviève and Picasso were agreed at the time that their romance should pass more or less unobserved. Hence there is no reference to her in any biography of Picasso. She figures neither in the supposedly exhaustive 'life' written by Penrose, nor more surprisingly in the spiteful but discredited memoirs of Françoise Salk, nor even in J. P. Crespelle's gossip-mongering compilation devoted to the women with whom, at different times, Picasso was amorously involved.

Yet Geneviève Laporte was privileged to witness several major episodes and personal dramas in Picasso's life which are more or less unrecorded, privileged too to be taken into his confidence with regard to troubling personal affairs, and privileged again to be able to listen on many occasions to Picasso telling her his views on painting as an art and discussing problems in connection with his own work. Finally, the friendship between Geneviève Laporte and Picasso was of such an easy and intimate nature that she saw and was able to understand more than most people of those (largely disguised) complexities of character and temperament which governed the actions, reactions and ideas of this forceful, but tortured, creative personality. And because Geneviève was a good listener, a sensitive observer and a persistent but intelligent interlocutor, who was fully alive to the all-time significance of everything she saw and heard in the daily life of which she was an integral part, she noted every detail and was careful to write it all down for her own satisfaction at the time. Geneviève Laporte is, therefore, an

invaluable source of first-hand information not only on what Picasso did and experienced in the decade between 1944 and 1954, on his attitude to the world around him, especially his relationships with a few close friends, and on his patterns of behaviour, but also on the workings of his character and the qualities of his mind.

Geneviève Laporte has been content, for two decades and more, that all of this precious information should remain locked away in her memory, because she had no private scores to settle with the past, nor any wish to attract to herself publicity or riches by misplaced sensationalism. Now that she has, at last, revealed all she knows, she needs no further introduction or personal presentation from me here, because in the pages that follow she has described herself and told how, when, where and at what age she came to meet and know Picasso and Cocteau. Geneviève Laporte truly loved Picasso, and there seems no reason to doubt that this love was reciprocal. But Geneviève has waited to talk about it until she felt that she could look back on the past with sufficient detachment to recount things as they were and in so doing present Picasso not so much in the fairest light as in the warm glow of a human entanglement.

Sunshine at Midnight – a factual record and an account of a moving and enriching personal experience – is not only a very remarkable, but also a fascinating, entertaining and gripping book. To start with, it is of biographical interest on account of what the author says touching the personal history of Picasso. Much of this has hitherto remained unknown and unremarked. Secondly, Geneviève Laporte has drawn a portrait of *the man* Picasso – she has no pretensions to being an authority on or critic of his art – which is vibrant, subtly shaded, life-like and built up gradually with a surprising intuitive awareness of his fundamental humility, his uncontrollable emotionalism, his generosity and his cruelty, his longing for human contacts and love and his victimization at the hands of his possessive genius. This is enough to make Geneviève Laporte's volume of memoirs a meaningful addition to the Picasso literature.

But I think that perhaps the outstanding merits of this book

are its honesty and sincerity, as well as the spirit of profound affection which inspires every sentence the author writes about Picasso, who thus comes alive in these pages as a truly sentient human being. Of course, there also lurked inside him another being who was a monster, as Geneviève Laporte realized. But then, no matter how one describes or analyses Picasso's nature, the opposite is just as likely to have been equally true. Not for nothing did Cocteau take to calling him *l'abominable homme des neiges* (the abominable snowman). Geneviève Laporte's volume seems to me a splendid successor to Fernande Olivier's delightful and touching memoirs of her life with Picasso in the period between 1905 and 1912. Picasso himself cherished that volume and frequently talked about it with admiration. He would, I am sure, have felt no less happy had he lived to read what Geneviève Laporte has written about a later period. As I went through the pages of the French edition of her book, I could hear once again the authentic voice of Picasso himself talking. Geneviève Laporte has captured the actual rhythm, the rapid switches of tone, from solemn to ribald, from witty to challenging, the flow of jokes and paradoxes, the hesitancy, the patient explanations, the impetuosities of his thinking, the unpredictability of what he might say next. Above all, she has caught and recorded some marvellously illuminating statements about art.

The text of *Sunshine at Midnight* has been delicately written and cleverly composed, it is in the best sense touched with a poetic spirit, but at the same time is wholly free from whimsy or sentimentality. There is also about it a simplicity and naïveté which give it charm, and a matter-of-factness which gives it permanent value as a biographical record. Lastly this book enshrines a human story, economically told, which has a poignant ending. 'It is marvellous to think that when I am gone,' Picasso said once to its author, 'someone who loved me will still be there to say true things about me and not just anything.' He knew, because he had suffered at the hands of others. How grateful we would be today to have at our disposal a first-hand account of the life-style and conversation of Leonardo,

Rembrandt, Velasquez or Goya written at the time by a friend or companion as loyal, as conscientious and as devoted as Geneviève Laporte.

Douglas Cooper
Argilliers, March 1974

Dawn is breaking over Provence. For once, it is a grey day and the light falls like lead on the ridges of the near-by Alpilles. What a task lies ahead of me! I want to tell what I know about Picasso from personal experience during seventeen years, from the time when we first met soon after the liberation of Paris in his studio in the Rue des Grands Augustins, to our last encounter by chance in a restaurant in St Tropez.

I don't know which weighs heavier on me this morning, the tug of war with my recalcitrant memory or the sight of the clouds scudding northwards. For the *mistral* too has joined the fray, and the clouds, unable to resist its force, are disappearing. So the sky at Les Baux de Provence is becoming a spotless, pure blue, as one expects it to be on a summer's morning.

Therefore I can no longer put off opening my precious casket of memories, which is cloaked in the dust of years. Inside, I shall find withered blooms all with the same odour, the odour of the past. Perhaps too some thorns and nettles will get caught in my fingers.

'Don't open it' whispers the almond tree, whose tall branches brush against the window ledge.

All the bushes and herbs of the scrub – the blue-eyed rosemary, the powdery thyme, the broom whose branches are covered in yellow sunbursts – lean towards the ground and offer the same advice. But already it is too late.

It was from Arles that I received a postcard one day, a photograph of the deserted arena. Right in the centre, where one would expect to see horses, picadors and matadors, Picasso had put his signature and the seven letters of his name were by themselves a glorious *paseo* preceding a *corrida*.

I was surprised by Picasso's love of bullfighting, which led him irresistibly to a seat in the front row of the arena at Arles or Nîmes, for Picasso loved animals and was always surrounded by them. I encountered Kazbek, a Saluki whose last days were spent in the Rue des Grands Augustins, along with a flurry of

pigeons – it would sound more poetic to call them doves, especially since they were the origins of the Dove of Peace. Later on, Picasso owned a boxer. When he had lived in 'the *bateau-lavoir* on the Rue Ravignan'[1] – that's how he always referred to his studio of those early days – Picasso had a cat for companion. Being very poor, he ate where he could get credit, and when he had exhausted the possibilities first of his street, then of his quarter, he discovered a *bistro* on the Avenue du Maine, on the other side of Paris, which was prepared to trust him. So twice a day Picasso went on foot from Montmartre to Montparnasse to eat, and on his long walk home at night looked in dustbins to find food for his cat.

Picasso knew that I shared his love of animals. At the time (1951), I had a small fox terrier bitch called Midjick. Picasso was much amused by Midjick and made several drawings of her. One evening he fetched me in his magnificent white Oldsmobile – by which I was obviously and quite genuinely impressed – to go and spend two days in the country. We had reached the limits of Paris before he noticed that Midjick was not with us and asked why. I said that I had not had the courage to take my dog in such an elegant car because she would leave hairs and soil it. Picasso immediately ordered Marcel, the chauffeur, to take us back to fetch Midjick, and the excited reception she gave us made Picasso very happy. He was delighted by the way dogs jump about to express happiness and thought it sad that men do not do the same.

How then could he explain his passion for bullfighting? For, of course, I taunted Picasso with getting pleasure out of a spectacle in which both the horse and the bull are treated with great cruelty. He began by advancing the argument that it was a better death for the bull than in a slaughterhouse, but I was not convinced, because I cannot see what there is to choose between plague and cholera. Then, somewhat embarrassed, he attempted to justify himself in my eyes by saying that it gave him a certain thrill to witness the survival of a Mithraic cult. Picasso fell silent and looked at me anxiously, as though he was afraid that I might laugh. However, when he saw that I was thinking this over, he

felt reassured and went on to reveal his belief in mysterious forces which govern the world. One phrase in particular – he very rarely used abstract words – recurred constantly when Picasso wanted to communicate his belief in something which he considered important: 'It's no laughing matter' or 'I'm not joking.' For example, my notes tell me that one day, talking about drawing, he used exactly these words: 'Drawing is no joke. There is something very serious and mysterious about the fact that one can represent a living human being with line alone and create not only his likeness but, in addition, an image of how he really is. That's the marvel! It's even more surprising than any conjuring trick or "coincidence" one has ever heard of.'

I have come to realize that, in my inner self, I now resemble the portraits Picasso made of me twenty years ago. Was it a case of prescience on his part? Or has the drawing impressed itself on me by some magic? One day, Cocteau was talking about things which he was supposed to have done, which were untrue at first but which nevertheless happened later, and he said: 'My legend has always preceded me. Events have always contrived to enable me to catch up with it.'

There was something ambiguous about the relationship between Cocteau and Picasso. Picasso's attitude towards all his friends was possessive, jealous and unpredictable. At the same time, he was very generous and always ready to help them when times were difficult. Yet there were very few whose success gave him wholehearted satisfaction. One morning, when I was on my way to the studio in the Rue des Grands Augustins, I read that Jean Cocteau had been elected to the Académie Française (March 1955) and imagined that this would give Pablo as much pleasure as it had myself. Jean wanted this consecration so badly because, as he roundly asserted, it had never been granted to a poet of his breed during his lifetime. I was therefore astonished to arrive and find Picasso coldly resentful. He had just completed a humorous drawing of a hideous bedroom, containing an iron bedstead with bars, on which was seated an elderly, pot-bellied couple, whose faces were the embodiment of stupidity and smugness. One – the woman I think – was reading a newspaper, while

3

the man was picking his toes.[2] Picasso, with a mocking laugh, handed me this drawing, every line of which conveyed ugliness, commonness and stupidity, with the comment: 'The woman is reading in the newspaper "Jean Cocteau has been elected a member of the Académie Française" while her husband is scratching his toes.' That was a side of Picasso which made my blood run cold. Yet with what artistry he guided his pen to convey the full bite of his malice.

Cocteau, who was well aware of the surprises and probable setbacks awaiting him during the round of visits he had to make to present his candidature for the Académie, had thought up in advance the following adroit explanation, 'People expect me always to do something unusual. Don't you think my entering the Académie would be really unparalleled?' And he said it so ingenuously, despite his lack of sincerity, that he could not fail to gain support.

At times, however, Cocteau had to recognize that Picasso's affection for him was not without reservations. In fact he began to refer to him familiarly, in about 1960, as 'the abominable snowman'. Cocteau knew that Picasso was irritated by his drawings and frequently complained 'Cocteau is always trying to imitate me.' Cocteau avenged himself by remarking to me: 'Picasso is trying his hand at metaphysics, but he knows nothing about it.' One night I asked Picasso why he took pleasure in saying disagreeable things about Jean. 'What's he done to you?' I said. Picasso's answer astonished me: 'It's all his fault that I met my wife.' He was referring of course to Olga Koklova, one of the dancers in the Diaghilev ballet, to whom Picasso had later handed over the Château de Boisgeloup near Les Andelys. Although they had been separated for many years, Picasso still regarded Olga as his wife, and only their son Paul bore the name Picasso. Picasso was genuinely fond of Claude and Paloma Gilot, also of Maïa, his daughter by Marie-Thérèse Walter, yet this did not blind him to the fact that they were not legitimate children.

Braque even said to Picasso when we were visiting him in Normandy: 'In matters of love, you have kept in line with the masters.'

4

Intrigued by the story about Olga, I decided to tell Cocteau of Picasso's grudge and ask a few questions. 'Oh, the liar!' said Cocteau in a tone of indignation. 'Let me tell you what really happened, because it wasn't like that at all. Diaghilev's company was leaving by train for a tour, in Italy I think. We – and that of course included Picasso – had decided to see the dancers off from the station. Just as the train was leaving we all leapt from the carriage. Not so Picasso: that old hypocrite had secretly bought a ticket and went off with the company – which naturally included Olga.'[3]

Picasso's relationship with Matisse was of the same order. He frequently visited Matisse when he was bedridden during his last years and being much in awe of any form of illness, used to recount how Matisse had fixed up a bed-table so that he could go on painting. None the less, when he began to talk about the discussions they had had together before and during the years of Cubism, Picasso would always mention, with a sense of irritation which had not diminished in forty years, Matisse's comment on the pictorial experiments in which Braque and himself had then been passionately engaged: 'In short, you are looking for the fourth dimension.' After which Picasso would add, with a smile of contentment: 'The silly fool had given me the key without realizing it!'

Picasso would even accuse Braque of having imitated him during the Cubist period.

On the other hand, Picasso's relationships with poets were of a very different kind. They were not unclouded, yet I believe there is truth in what Cocteau wrote to me in a letter: 'I have always thought of Picasso as a poet . . .' Picasso talked with great affection of Max Jacob and Apollinaire. When he came back to Paris in 1902 Picasso shared with Max Jacob a tiny room which had only one very narrow bed. Max, who was a salesman, left early in the morning for the shop where he worked. Picasso, who painted all night, waited for this moment to take his turn in bed. 'Max loved the theatre . . . especially *La Bohème*, which made him weep each time we went to it . . . We often went as well to the Théâtre des Batignolles, but there we were thrown

5

out by the police for eating sausages.' Remembering this Picasso burst into fits of laughter. 'Max had a great comic gift. He would give little performances for me alone, reciting monologues for example or acting out a scene in which he himself played several different characters. I too have some talent as an actor. Look, here's Charlie Chaplin being hit on the head by a brick.' And in fact Picasso could do a perfect imitation of Chaplin, pulling his head down to his shoulders and rolling his eyes up into his head.

Some years later, Chaplin came to spend a few days in Paris and stayed at the Hotel Ritz, much to the surprise of several gentlemen of the Press. When I saw Picasso – Chaplin was anxious to meet him – he greeted me gaily with: 'Charlie's in Paris. Some people are indignant because he's a Communist and staying at the Ritz. But after all they couldn't put him in the lavatories.' This sort of remark did not signify however that Picasso, who was a party member, felt a spiritual kinship with all other Communists throughout the world.

Picasso joined the Communist Party after the Liberation. He showed me his membership card when I arrived at the Grands Augustins studio one afternoon in the winter of 1944, and he was quite as amused as I was to see himself described as 'Comrade Picasso'. At first sight, it seemed inappropriate for him to have a political allegiance, especially that one. So I questioned him: 'Have you read Marx? Are you a Marxist?' His answer, as I expected, was in the negative. Myself, I had by then read both Politzer's articles in Communist magazines, and the red – a rather dark red – book by Stalin, *The History of the Communist Party*. What is more, through my membership during the Resistance days of the F.N.E.,[4] which had also gained me admittance to Picasso's studio, I had been associated for the most part with Communists. I was even ready to follow these school mates into the party, though I felt that before doing so I had to become a Marxist. I did my best, but it was in vain, because there were too many arguments with which I could not agree. Picasso however had not even thought of opening a book on the subject.

We joked about it for a few moments then he suddenly became

6

serious and started to explain: 'You see, I am not French but Spanish. I'm opposed to Franco. And the only way I have of publicizing this is to join the Communist Party and demonstrate that I am on the other side.'

Aragon and Eluard, both party members, were overjoyed, though Eluard had far fewer illusions than Aragon concerning the true colour of Comrade Picasso's 'Communism'.

Aragon served as an intermediary between Picasso and the Central Committee. As with all famous people, Picasso's patronage was continually being solicited, whether for charity sales or gestures of solidarity with some faction or another. In his generosity, Picasso was always obliging, even for the Communist Party. At the time, Fougeron was the artist most highly esteemed by the party, whereas Picasso's paintings were looked down on as 'decadent' by the Russians. Nevertheless it was to Picasso that Aragon went to ask for a portrait of Stalin, which was duly executed.[5] The day Aragon went to fetch the drawing, he was in raptures over what Picasso gave him and went off to show it to the Central Committee. A few days later, he returned shamefacedly because the Committee had disapproved of the portrait. Picasso burst into a towering rage.

'Those fools! I had deliberately drawn Stalin's forelock so that it turned into a proletarian cap. Now they don't want Marshal Stalin to be proletarian!' There followed a torrent of insults aimed at 'them'. Then: 'Serve them right if I tear it up and refuse to do another.' I don't remember what happened to this 'portrait of Stalin' after that.

Aragon's missions were always going wrong. On another occasion, he wanted a drawing for the Peace Movement[6] and Picasso said he could choose whatever he liked from among those in the studio. Aragon noticed a series of drawings of pigeons and waxed enthusiastic: 'Those beautiful doves . . . that's just what is needed for peace.' With that the dove took wing and was soon to be seen everywhere – reproduced on scarves in four different colours, symbolizing the races of the world, on records by Paul Robeson and so on. But hardly had Aragon left the studio than Picasso was chuckling with glee: 'Poor old Aragon!

His dove is a pigeon. But then he doesn't know anything about pigeons. And as for the gentle dove, what a myth that is! There's no crueller animal. I had some here, and they pecked a poor little pigeon to death because they didn't like it. They pecked its eyes out, then pulled it to pieces. It was horrible. How's that for a symbol of Peace?'

All night the *mistral* has been blowing furiously. At sunrise its fierce assault on the delicate light seems provocative, yet the *mistral* which is master in Provence, also contributes to its gentleness. So it was with Picasso, another 'master' who loathed being called one.

One summer's morning we were wandering through the half deserted streets of St Tropez when a young man about thirty years old, carrying a bunch of gladioli, came up and spoke to Picasso. 'Good morning, Master. I am a painter and I have great admiration for your work. My studio is nearby and I would like to show you my pictures.' Picasso, aghast, was unable to get in a word. But when the young man stopped talking he asked him sweetly: 'What are you doing with those flowers?' The painter, somewhat surprised, stammered out: 'I'm going to paint them.' To which Picasso rejoined, still in the same sweet tone, which with him one could never trust: 'Why do you paint flowers?' 'Because they smell good,' answered the painter. 'Are you married?' 'Yes.' 'Well, go fetch your wife, I'll fuck her and afterwards you can smell my cock. You'll soon find out that it smells better than flowers.' Picasso burst out laughing and carried me off, leaving the poor young man standing in the middle of the street. But when he stopped laughing, Picasso, delighted by the excellence of his own ribaldry, looked at me slyly and added: 'I loathe being addressed as "Master" and always want to say "master of my bottom".'

We thought we had disposed of the painter with the gladioli, but this was to overlook the fact that in those days St Tropez was little more than a village, around whose harbour most of the

inhabitants gathered in the late afternoon. That same evening we were dining outside the restaurant L'Escale, where Picasso had discovered the joys of crayfish and champagne and wanted only these for his supper, which suited me too. On reflection, however, I think he may have been trying to please me rather than himself. For, as Eluard once pointed out to me, Picasso never ate more than he needed. He was always abstemious, generally drank only beer or mineral water, very little coffee, no alcohol and took no stimulants, except heavy French cigarettes.

Well, we were coping with our crayfish when the painter reappeared, having no doubt had time meanwhile to digest Picasso's outburst. He came up to our table, stood there for a few instants, then seized a chair and sat down. Picasso was furious but dared not say anything, while I concealed my mirth in anticipation of what would ensue. The painter was still determined to persuade Picasso to visit his studio. But Picasso parried with a 'Later on, later on.' The painter however persisted: 'I'm Austrian . . . here for the summer – give me at least some advice.' Picasso, deeply absorbed in the task of cracking the shell and eating his crayfish, suddenly said: 'You're Austrian. Have you a father?' The painter answered affirmatively with a nod, after which Picasso continued: 'Where does your father live?' 'In Vienna.' Picasso stopped looking at his plate, stared fixedly and grimly at the young man, though a faint smile puckered the corners of his eyes, and blurted out: 'Then go to Vienna, bugger your father . . . and after that you'll do some good painting.' He stretched out his hand and added: 'Goodbye, sir.' Dumbfounded, the painter got up and left . . . this time for good.

When we were once more alone, Picasso, still in a serious mood, said: 'That idiot won't follow my advice, and yet . . . take the case of Dora Maar for example. She was a photographer as well as a painter, and so long as she was crazy her painting was good. But they shut her up, gave her treatment, and when she was cured her painting was very bad.'

The meal over, Picasso and I set out for the narrow Rue des Bouchonniers, where Dominique and Paul Eluard had found us a small house for the summer, with red-tiled floors like those in

the Grands Augustins. Picasso liked walking barefoot on them. The night was bright, and we saw very few people as we wandered through the little streets of the town. Picasso took up our earlier conversation: 'I was telling you about Dora Maar. The same applies also to poets. Poets with a curse on them should remain that way. Once they have been saved, they cease to be poets. Look at Eluard ... since he's been married to Dominique he doesn't drink any more and doesn't play around. You know, Eluard has his curious side. He wants his friends to sleep with the woman he loves, because he maintains that if his friends are fond of him they should also be fond of his wife. Dominique doesn't share this view, naturally, but as for Nusch ... don't you remember?'

Of course I remembered. My earliest recollection of Nusch goes back to September 1944, when Picasso sent me to see Eluard, who lived in a small apartment in an old building in La Chapelle, a working-class quarter of Paris. I rang the bell and the door was opened by a dark-haired woman wearing an apron, who had a strange, rather wild beauty, and was grasping a kitchen knife. This was Nusch, who was busy peeling potatoes. Immediately behind her appeared the gaunt silhouette of Eluard looking just as he did in some photographs Picasso had shown me. He added a certain brightness, with his whitening hair brushed sharply back, revealing a wide forehead and eyes like starfishes. The walls of the small apartment were lined with books and paintings, among which I recognized some portraits by Picasso. Some of these I was to see again a few years later in the apartment on the Rue de Gravelle where Eluard lived with Dominique, his third wife, and where he died.

I reminded Picasso of my first meeting with Paul and Nusch, also of how this glimpse of the poet's wife peeling potatoes in the kitchen conflicted with the dreams of the schoolgirl that I was in those days. Picasso pursued his train of thought: 'Nusch was admirable, just what Paul needed. Paul, you know, wanted me to sleep with her ... but I didn't want to. I liked Nusch very much, but not that way. And Paul was furious. He said that my refusal proved that I was not really his friend. Sometimes, Paul

would disappear into a hotel with a whore, while Nusch and I waited and chatted in some café near-by.'

I then asked Picasso if he remembered the first piece of advice he had given me when, at that very same period, I used to visit him on Wednesday afternoons. I was attending the Lycée Fénelon,[7] close at hand, and we had no classes on that day. Normally, Picasso only received visitors at the end of the morning and kept the rest of the day free for work. But the whole afternoon was given up to me.

'What advice did I give you?' 'I asked you – for like all adolescents I was very frightened of life, of the future, of reaching the age of twenty, that critical time one hears so much about – "What do you advise me to do when I'm twenty?"' Whereupon Picasso, with something of a mischievous look, had offered the following advice to his young friend: 'If you meet a good-looking boy, fall in love with him.'

Picasso roared with laughter. 'Is that the advice I gave you? No doubt, I was thinking of myself. You know, if I didn't look in the mirror occasionally, I wouldn't realize that I have aged.'

That year (1951) he was actually seventy, yet he could ramble with me up the steep hills behind La Garde-Freinet, or take long walks among the vineyards round Grimaud and Cogolin. He would swim for a long time at St Tropez without feeling in the least exhausted. And he never suggested stopping for a rest.

Once again Picasso – who constantly changed his tone during any conversation – became serious: 'The advice I would give you nowadays – and I don't at all share Eluard's view – is that love is a language. Talk it with everyone and you'll have the Tower of Babel . . . then you'll be lost!'

This is the third day of the *mistral,* and as everyone who is familiar with Provence knows, if it carries on into a fourth day it can last till the sixth. On the other hand, it can stop as suddenly

as it begins. On this third day, the cicadas, who had been silent, have begun to sing again in the nettle-tree, whose dense foliage is being tossed around by the wind. My little house, solidly planted on the ground, remains unmoved and proudly waits for it to finish.

My memories, like the wind, are in turmoil. At some moments they come with a brutal rush, carrying with them remnants of happiness uprooted in some remote, well-protected garden. At others, all is calm. A great peace descends, enriched by so much that I had thought forgotten. I relive my own emotions as though they were of the present moment. Once again, as at the time, I am unaware of what will happen in the next few minutes, minutes which in the end added up to seventeen years – for there comes a time, after all, when one has to make a final reckoning.

Picasso summed up his married life in one disenchanted sentence: 'You can go on talking about love, but there comes a moment when it turns sour, and that's when you have to pay the laundry bill.'

Picasso was influenced by one book, *The Kreutzer Sonata* by Tolstoy, whose intellectual conclusions he fully accepted. He gave me this book to read soon after our meeting. Picasso also advised me to read Balzac's *Le Chef d'œuvre inconnu*, for which I subsequently discovered he had made illustrations. A few years later, when we knew each other better – did he think I might scoff? – Picasso made me read St John of the Cross, saying that he was the poet who had written most beautifully about love. Then came Sade. 'Such a free spirit' he would remark, and then lose himself in thought. One day Picasso gave me *Le Chant des morts* by his friend Reverdy,[8] the pages of which he had ornamented with thick red lines, which at first sight looked like a succession of full stops and commas. 'Nothing,' he said, 'is harder than drawing a line. Nobody realizes how much you have to think about it.'

The phrase 'to think about a line' cropped up frequently, and when I gave him a disbelieving look, he replied: 'Well, you shall try.'

Picasso fetched two sheets of paper and drew on each of them

a vase, a sort of pitcher standing on a broad base, flat and rounded in the middle with a narrow neck which flared out at the top. It was like some of those he had made with Monsieur and Madame Ramié of the Madoura pottery in Vallauris. Picasso then handed me one of the sheets of paper and kept the other himself saying: 'I'm going to complete the owl.' And in a few instants he had added two ovals on the neck, which became eyes, and a V with a line across it, which became a beak. Two thick black lines drawn in the middle produced wings, while two rows of dots in the centre convincingly gave the illusion of feathers. After that, he handed me the pen and Indian ink saying: 'It's your turn.' I thought what he had done was child's play and accepted the challenge with a laugh. The result was disastrous. No comparison was possible. The lines I drew were heavy, meaningless and clumsy: where his owl was really black and white, mine seemed grey. I looked shamefaced; he was delighted. And then, with that tenderness and patience which I had come to know so well, he tried to console me.

'When you were little' – he was alluding to the time we first met, when I was, to say the least, adolescent – 'I used to give you chocolates (true enough!). Now I'm going to explain things to you. You know my nephew Javier . . .? well, I'm teaching him the science of lines. Make the heaviest part first, otherwise your line will seem like an acroplane which is trying to take off but is continually having weight added to it. Even though I have used black, my owl is white, while yours looks grey. Your black spots are too heavy and too far apart.'

The group of portraits of myself which Picasso drew in Indian ink have this same whiteness. I don't know how he achieved it, but as soon as he made a line his paper began to shine like a piece of old silver when it is being polished. These portraits were drawn in St Tropez with a pen made from a reed used for making fences and known locally as a *cannisse*. 'Just like Van Gogh,' he remarked. Some others were made over a basis of eyebrow pencil. Another day, he made a portrait-collage of me. My dress was cut from a book jacket, which he stuck down with nail varnish. He drew my face with a ball-point pen and then,

13

underneath the shift, which could be lifted, gave me nipples with lipstick. He was delighted by his little inventions.

'In my time I've discovered a number of things which other people are just beginning to find out about. The ball-point pen for example. I experimented long ago with a flow of ink between two ball bearings. Camping too I tried long before it became fashionable, when I went off with two friends into the mountains in Spain. We met no one for a month, lived naked, and painted on the rock surfaces. We were seen only by poachers – though we only knew that when we got back home.' A dreamy look came over Picasso's face while talking about his earliest youth, then he added: 'I love stark, desolate landscapes with bare rocks'.

I commented that he had painted very few landscapes. 'Well, I haven't seen many. I've always lived within myself. My own interior landscapes are so amazing that nature could never show me anything as beautiful.' Yet he had painted many an 'open window' at St Raphaël, Royan and elsewhere. 'But an "open window" isn't a landscape, it's something quite different. Anyway, that was at the beginning of the war, and a window which opens when everything around is collapsing makes an impression, doesn't it? It gives hope.'

N'es-tu pas notre géométrie,
fenêtre, très simple forme
qui sans effort circonscris
notre vie énorme?

Celle qu'on aime n'est jamais plus belle
que lorsqu'on la voit apparaître
encadrée de toi; c'est, ô fenêtre,
que tu la rends presque éternelle.

Tous les hasards sont abolis. L'être
se tient au milieu de l'amour,
avec ce peu d'espace autour
dont on est maître.

*　　*　　*

14

Fenêtre, toi, ô mesure d'attente,
tant de fois remplie,
quand une vie se verse et s'impatiente
vers une autre vie.

Toi qui sépares et qui attires,
changeante comme la mer —
glace, soudain, où notre figure se mire
mêlée à ce qu'on voit à travers;

échantillon d'une liberté compromise
par la présence du sort;
prise par laquelle parmi nous s'égalise
le grand trop du dehors.

* * *

Comme tu ajoutes à tout,
fenêtre, le sens de nos rites:
quelqu'un qui ne serait que debout,
dans ton cadre attend ou médite.

Tel distrait, tel paresseux,
c'est toi qui le mets en page:
il se ressemble un peu,
il devient son image.

Perdu dans un vague ennui,
l'enfant s'y appuie et reste;
il rêve . . . Ce n'est pas lui,
c'est le temps qui use sa veste.

Et les amants, les y voit-on,
immobiles et frêles,
percés comme les papillons
pour la beauté de leurs ailes.

RAINER MARIA RILKE

15

Window, are you not our geometry,
a very simple form which effortlessly
encloses the vastness of our life?

The loved one never has more beauty
than when one sees her appear
within your frame, because, o window,
you render her almost eternal.

All risks are excluded. The being
is there at love's centre,
with a restricted space around her
of which one is master.

 * * *

You, o window, measure of waiting,
many times refilled
when one life overflows and impatiently
strains towards another life.

You, who separate and also attract,
as changeable as the sea –
mirror in which, suddenly, our face is reflected
commingling with whatever one sees on the other side;

reminder of a freedom compromised
by the intervention of fate;
aperture through which we screen
the great excess of the world outside.

 * * *

You, window, endow everything
with a sense of our rites:
someone standing within your frame
is either waiting or meditating.

For the absent-minded or the lazy
you provide a context:
he is not unlike himself,
he becomes his own image.

Overcome by an indefinable boredom,
a child will settle and remain;
he dreams ... It is not himself
but Time that wears out his coat.

And lovers too one sees there,
immobile and frail,
pierced like butterflies
for the beauty of their wings.

<div align="right">

RAINER MARIA RILKE
(translated by Douglas Cooper)

</div>

Picasso's face hardened. War ... His protest against it bore
the titles *Guernica, War and Peace, Massacre in Korea.*
'You know, the evil thing about war is that men are killed.
Florence has been destroyed – and of course that's sad – but
surely it's much sadder that those who might have rebuilt it
have been killed. Destroying buildings is simply part of the
game, a way of making people understand that there is a war on.
Otherwise they wouldn't believe it. That's the only significance
it has. It's not as a result of destroying Florence that its destroyers
either won or lost the war.'

Monsieur Seguin's little goat was right, thyme on the hillsides is
juicy whereas thyme in the valley dissolves into dust![11] Rosemary
too has a subtler perfume on hillsides. The cornflowers open their
petals in the shade of the pink-fingered honeysuckle, the *immor-
telle* of the hillsides is fleshy and blooming, whereas in the ravines
it looks funereal. Coming round a bend in the path this morning
I startled a hare, which bounded away into the scrub, while
partridges flew in all directions. In the oblique rays of the early
morning sun, I felt a shadowy presence following like some great
beast in my footsteps. The presence was Pablo's. He had greatly
enjoyed our walks through the forests of cork trees which cover
the hillsides of the Var. He relished the calm of La Garde-Freinet,

a Provençal village where old women, wearing a little white lace cap, sat out in the sunshine peeling courgettes, though he commented sadly: 'In a few months or with luck a few years, you'll see some Belgian lady come along, buy a house and do a lot of work on it to make it look pretty. Other Belgian ladies will then follow and do the same thing. And one fine day the place will be ruined.' Picasso cannot have known the truth of what he was saying.

We stayed at the Auberge Sarrazine, an old-fashioned place, rather dirty, and kept by a dark-haired woman with an unpleasant face. By chatting with our chauffeur, Marcel, she had learned the name and occupation of her illustrious guest. In those days, Picasso did his best to avoid not only journalists but also photographers, so although his name was well known, his face was unfamiliar to the general public. That gave him the advantage of being able to walk into even the most crowded places – exceptions were few – without being bothered. On the second day of our stay the innkeeper, who was serving at table, asked him, with signs of embarrassment, whether he really was Picasso. Pablo, who loved playing on words, answered: 'Well, I don't know . . . I try to be!' The innkeeper plied her customer with questions until she was sure of his identity and then said: 'All right, paint me.'

'Sure,' said Picasso, 'fetch me a comb.'[12]

On another occasion, the owner of a restaurant (not L'Escale) in St Tropez ventured an equally tiresome request: 'Don't you have a plate you could give me?'

Picasso, irritated but at the same time unnerved by the impertinence of his interlocutor, answered that he did not walk around with plates under his arm.

At the restaurant Le Pyramide in Vienne he was recognized by Madame Point, who refused to allow him to pay the bill. This made Picasso furious. 'You see, if I don't want to be put under an obligation for things like that, I have to say "Thank you" and send a drawing. That's why I prefer to pay. Anyway, I only accept presents from friends. Take the case of the Oldsmobile. It was given to me by an American to whom I in turn had to give

a present.[13] And on top of that I had to pay the customs duty. So it ended up by being a very expensive car – more especially since I don't know how to drive. I might manage if left to my own devices and not shown. I'd find out. But that's forbidden, and I've never been able to have myself properly taught.'

Picasso thought for a moment, then started to laugh. 'Once, you know, some people said to me "You must learn to drive, because driving stops one from thinking." They couldn't understand why I became angry and shouted at them "But I *want* to think." That's funny, isn't it?'

That evening we went to our bedroom. I don't have any clear memory of it apart from the much-repaired shutters which seemed about to fall off every time one opened them. There was no W.C., but a wash-basin and a *bidet* in a corner. A room for a travelling salesman. Picasso looked around admiringly: 'I like things which are ugly and ageless. What an extraordinary room for me, and I can see so many things . . .'

Picasso and I had been good friends for seven years, but this sort of remark surprised me, because he loathed dirt. He persecuted Inès, his devoted housekeeper at the Rue des Grands Augustins, with precise instructions on how to keep the place clean. No detergent was to be used for the bath-tub: Picasso would allow nothing but household soap and a stiff brush. While as for the large table on which he piled everything. Inès could clear a corner to serve lunch at about 2 pm for Picasso and any friends he had invited, but otherwise his orders were strictly 'Don't touch!' Even I, whose childhood had resounded with my mother's oft repeated 'Don't touch', was looked at askance and similarly admonished whenever I approached this magnificent table, which was all of 10 feet long.

I learned one day how Picasso, exhausted by the poverty of his life in Paris, had returned to his parents' house in Spain. He arrived in the evening and, worn out by the long journey, went straight to bed. The following morning, while he was still asleep, his mother brushed his clothes and polished his shoes, so that on waking Pablo found that he had been deprived of 'his dust of Paris'. He told me that this put him in such a terrible

rage that he almost reduced his mother to tears. However, he was ready to admit that he 'had no grudges against his parents. They were always very nice to me, although I left them very soon, since I was on my own in Madrid at the age of fifteen.'

Picasso threw nothing away and dust, like anything else – old envelopes or bits of paper – contributed to his riches. Things would pile up, yet he always knew where to find anything he wanted. How often I saw Picasso break off in the middle of a conversation with friends when reference was made to something which had happened perhaps decades previously and say 'Wait!' Then he would disappear, ferret around for a few moments and come back with a triumphant look on his face as he showed what he had gone to look for.

As soon as he was able, Picasso started to set aside places in which some part of his life was preserved. There was, for example, the fine apartment on the Rue la Boétie where after 1919 he had lived with Olga and experienced his first years of real success. For Olga, he bought a car and engaged a chauffeur, Marcel, and when, thirty years later, the same Marcel smashed up the Oldsmobile, Picasso fetched out of the garage an ancient Hispano-Suiza which he had kept from those days. Marcel was originally dressed in chauffeur's livery. But after Picasso separated from Olga, who received a handsome annuity and went to live at the Château de Boisgeloup, Marcel was told to 'undress'. And Picasso was surprised to find that poor Marcel was mortified by this. 'I thought he would like it, but in fact I had taken something away from him. One can never be careful enough when dealing with the lives of other people. Once, when I was a boy, I saw a spider about to kill a wasp which was caught in its web. Oh, I said to myself, that horrible spider is going to hurt the poor wasp. So I took a large stone . . . and then discovered to my horror that I had killed both of them.'

This modern morality in the manner of La Fontaine led us on to the theatre, which Picasso loved. He took a chair, straddled it, clasped its back in his arms, started to laugh in anticipation like a child at a puppet show, and said: 'Do some theatre for me. Molière.'

Picasso had a predilection for *L'Ecole des femmes*, especially the scene where Arnolphe takes a stroll.[14] I had to play both the old greybeard and Agnès, and during Agnès's speech with its succession of bows and curtsies, Picasso was in fits of laughter. He also wanted me to do *Les Femmes savantes*, then La Fontaine. As I had gone through the same scenes an infinite number of times, I supposed that Picasso knew them by heart, and therefore suggested that he himself should take one of the parts. But he refused: 'Because of my accent!'

He became thoughtful, then asked in a tone of amazement: 'How come that you speak without an accent although I have been in France much longer?'

Picasso got up with a bound: 'But I can sing you a song. I am going to teach you *La Cucaracha.*' He began. There was laughter in his eyes as he slyly watched for my reaction.

Todas las mujeres tienen
En el pecho dos melones
Y un poquito mas abajo
La fonda de mi pistola
*La cucaracha, la cucaracha . . .**

I laughed, which made him happy, but pointed out that he was cheating by singing in Spanish. 'Wait a minute. I also know something in French.'

Quand j'danse avec le grand frisé
Il a une façon de m'enlacer
J'en suis malade . . .†

'What do you think of that? It's an old-time popular waltz. I learned it at the Lapin à Gilles. That was a shady dive, you know. Poor Frédé one day had a real murder on his hands: they killed

* Every woman has in her bosom two melons, and a little lower down a lodging for my pistol, La cucaracha, etc.

† When I dance with the tall, curly haired one, he has a way of holding me which is quite upsetting.

his son. I think Frédé was a ruffian. But we enjoyed having a drink there in the days of the *bateau-lavoir* of the Rue Ravignan. Dullin you know was one of our group.[15] He always seemed to us the least gifted of all our actor friends. He was hunch-backed, ugly and talked through his nose. What was really funny about him were his brothers. Dullin came from Lyon, from a very poor family with fourteen or fifteen children – he himself didn't know how many. At regular intervals he would get a letter asking him to go and meet one of his brothers at the Gare de Lyon. The brother would arrive, they would embrace each other, and a few days later he would disappear. Time passed, and then another brother would arrive. Dullin didn't even know them.

'I knew Harry Baur too.[16] He left his girl friend in my care, and every evening she and I would go and watch him perform.

'We made up a song about Marie Laurencin which infuriated Apollinaire. Marie was pregnant by him and had to have an abortion. She was always, you know, rather affected – given to fainting. You see what I mean. Well, one day as she and Apollinaire stepped through the door, they were greeted by us bellowing at them a song we had written:

Ah qu'l'envie me démange
de te faire un ange
de te faire un ange
en chatouillant ton sein,
*Marie Laurencin, Marie Laurencin!**

to the tune of the well known popular song: *Ah, qu'l'envie me démange d'aller en vendanges.* They nearly walked out.'

Any evocation of his youth always made Picasso happy. He lived it over again with almost as much intensity as he had originally.

'Then there was the supper party for the Douanier Rousseau.

* Oh, I'm itching with desire to make you an angel,
 to make you an angel,
 by tickling your breast,
 Marie Laurencin.

That was a jest, you know. No one believed in his talent. But he took it seriously and wept with joy. After that there was no going back.'

I remember that on the walls of the very austere room in which Picasso lived in the Rue des Grands Augustins, there were two paintings, and two only. One was a so-called Corot. The other, a tiny water-colour, was of a cock in a farmyard. This was Picasso's first painting, done when he was seven years old. He greatly treasured a painting by the Douanier Rousseau which he had bought for five francs. Paul Rosenberg one day offered him ten million for it, but Picasso, who hated selling anything, refused.

Picasso was always surprised and saddened when he discovered that friends – and he was generous to them – were treating his presents as negotiable assets. He cited the sculptor Adam[17] as an example: 'I gave him a painting, which he sold for less than it was worth and bought a motor-cycle with the proceeds.' Nevertheless, later on, when Adam had no place to store his sculptures and had to destroy several of the largest because 'it was cheaper than moving them', Picasso lent him a studio, just as he had lent an attic to Jean-Louis Barrault in his early days as an actor.

On more than one occasion, Eluard had to sell everything he owned by Picasso in order to live, yet Picasso, hurt as he was, replaced them with other paintings. Paul even sold a portrait of himself in order to have something to give to the France–Espagne Committee.

Talking to me one day about the venal aspects of any gesture he made, which were beyond his control, Picasso, who had made and given me several drawings of myself, said: 'If one of your friends tells you that these "little drawings" have a monetary value, tear them up there and then in front of him.' I was often tempted to follow this provocative counsel for, with the exception of Jean Cocteau and Alain Cuny,[18] I have had to put up with being told this by virtually every other friend who has seen them. However, as far as I am concerned – and Picasso was aware of it – there never has been and never will be any question of my parting with these drawings.

One morning, I met Youki, the widow of Robert Desnos,[20] in the Grands Augustins studio. She had come round to give Picasso a copy of her book containing letters which Desnos had written to her. Picasso thanked her graciously, but as soon as she had left he exploded: 'It's just as if you were to go reproducing your little drawings all over the place. Those are my love letters.' His face clouded over: 'The terrible thing is that I'm like King Midas. Everything I touch turns to gold, and the people close to me can't take it. Nor can anyone else. Look at the Ramié couple in the Madoura Pottery. I've made not only their fortune but that of the whole village of Vallauris. If the things I really love – water, the sun, love – could be bought, I'd have been ruined long ago.' Picasso looked at me with great tenderness. Was I too going to be assimilated into the group of those closest to him?

'You know, a lot of nonsense is talked about this subject. For example, it is considered a reproach to say that some woman loves a man for his money. What's wrong with that? What matters is that she should love him, and I don't see why it should be better to love him for his long nose rather than for his money.' This was a theme to which Picasso often returned. 'Of all the women who have been in my life, I have given less to you than to any other. Why didn't you want me to buy the house in the Rue des Bouchonniers? I'd like to give you some gold, not because it's valuable but because it is a symbol of love. Gold is sunshine.'

The sun had shone on our friendship virtually from the first day. When I met Picasso he still had an impressive lock of white hair which fell across his forehead, but later he had it cut. I was dismayed and railed against Aragon who was happy it had gone. Picasso always hoped that it would grow again, but alas the hair at the back of his head grew and began to curl whereas his forehead remained bare. While he still had his white forelock, Picasso gave me a small photograph with the following inscription: *Soleil caché au creux de la main.**

A few years later when I went to see him at the Rue des Grands Augustins, Picasso hurried towards me rather timidly holding out a piece of newspaper (*L'Humanité*) on which, in his sloping

* Sun hidden in the hollow of the hand.

24

hand, he had written with obvious artistry: *Ange du soir changé en herbe tendre et matelas de plume.**

Later still I was to be honoured with the following inscription on a photograph in which, with good reason, he thought he looked like Baudelaire: *La main tend au brasier les doigts pleine de regrets.*†

Picasso was a sun all on his own. He lit up, burned, consumed and reduced to ashes anyone who approached him, not even sparing himself. When Cocteau was talking, some time in 1960, about the isolation with which Picasso had to contend, he remarked: 'He's always been afraid of ties. He's always destroyed anything which threatened to occupy a place in his life. So it's not surprising that he's solitary nowadays.'

Pablo himself said to me: 'I've never been able to think of myself, and no one has ever bothered about me. I have always been afraid of hurting other people, perhaps through cowardice. Take Françoise for example: I've never loved her. But she's like a cup full of memories which I don't want to drink from any longer; on the other hand I don't want to smash it. So what am I to do?'

Eluard, who really understood Picasso's inner workings, maintained that: 'Picasso has only ever done in life what he intended to do. And that's to his credit, because it hasn't always been very easy.' Finally Paul gave me this bit of advice: 'With him, always be your natural self.'

September at last! The depressing stability of nature in August is over.

Once again the light in the woods has become a delicate celebration of fragile foliage. Provence yields to the idea of Provence, free of wasps and the *mistral.* I thought I had left behind, on the rocky paths which wind through the scrub, my

* Angel of evening transformed into delicate greensward and feather mattress.
† The hand, full of regrets, extends its fingers towards the brazier.

nostalgia for those crowded moments of which I shall never experience the like again now that my life is on its downward path.

The shadowy presence, the memory of Picasso, both almost physical, have accompanied me on my solitary wanderings through the Alpilles. How deserted they are! Yet with his presence alone he could populate them. Meanwhile my super-self – to use an accepted new word – is struggling hard to resist the invasion of my thinking self by fragments of past history. Where is the entrance into that very private realm designated 'love for Picasso'? And what can I say about it without giving away too much? For several weeks now, I have been looking for the way in, though the fault does not lie with my memory. Quite the contrary, for day after day my memory purrs with delight over what is recalled, while my conscience persists in its censorship.

How can I find the courage to write: 'I believe that I was the only profound love of Picasso's life and probably the last one'?

'Love is still in the making', he would say to me, 'and I hope we achieve it.' 'I've never wept over a woman,' he confessed, wiping away his tears and mine when he was leaving Paris and our haven of bliss in the Rue des Grands Augustins to go back to Vallauris for a while.

A few days later I received the following note from him: 'Possibly, and I even believe probably, I shall be in Paris on Sunday.' It was Sunday and the telephone rang: 'Hello. Is that you? It's me.' No more, for Picasso loathed the telephone and was very cautious about using it. Obviously he didn't know anyone's number, not even his own. So to keep track of mine he had written it on a bit of paper which he guarded jealously (in every sense of the word) in a little black pocket book, along with his spectacles and a small photograph of Paloma Gilot, the daughter of Françoise, who seemed to be his favourite child.

As a matter of fact, Picasso appeared to be surprised by his preoccupation with her: 'When she's in the next room (in Vallauris) making a noise, I get angry because she disturbs me. But if she makes no noise at all, I get frightened and go in to take a look.' He laughed, for he did much the same with me. I

26

sleep soundly and without stirring – so they say – and I would be woken by Picasso 'to make sure you're not dead. I can't even hear you breathing.' I discovered subsequently that in *Plain-Chant* (1923) Cocteau had written a poem about this same nagging doubt:

Je n'aime pas dormir quand ta figure habite,
* La nuit, contre mon cou;*
Car je pense à la mort laquelle vient si vite
* Nous endormir beaucoup.*

Je mourrai, tu vivras et c'est ce qui m'éveille!
* Est-il une autre peur?*
Un jour ne plus entendre auprès de mon oreille
* Ton haleine et ton coeur.*

Quoi, ce timide oiseau, replié par le songe
* Déserterait son nid,*
Son nid où notre corps à deux têtes s'allonge
* Par quatre pieds fini.*

Puisse durer toujours une si grande joie
* Qui cesse le matin,*
Et dont l'ange chargé de construire ma voie
* Allège mon destin.*

Léger, je suis léger sous cette tête lourde
* Qui semble de mon bloc*
Et reste en mon abri, muette, aveugle, sourde,
* Malgré le chant du coq.*

Cette tête coupée, allée en d'autres mondes,
* Où règne une autre loi,*
Plongeant dans le sommeil des racines profondes,
* Loin de moi, près de moi.*

Ah! je voudrais, gardant ton profil sur ma gorge,
Par ta bouche qui dort
Entendre de tes seins la délicate forge
Souffler jusqu'à ma mort.

Jean Cocteau

I have no wish for sleep when,
 At night, your face is lodged along my neck;
For my thoughts turn to death which arrives so fast
 And puts us to sleep forever.

I will die and you will live: that is what arouses me.
 Is this another fear?
One day to hear no longer your breath and your heart
 Close to my ear.

Would this timid bird, coiled up in dream,
 Desert its nest,
The nest in which our body, with two heads,
 Extends into four feet.

Oh, that such great happiness,
 Which ends with morning,
Could last forever, for the angel entrusted with tracing my path
 Thus alleviates my destiny.

Weightless I am beneath this heavy head,
 Which seems to be part of me
And remains under my protection mute, blind, deaf,
 Despite the crowing of the cock.

This severed head, which has departed to other worlds
 Where other laws prevail,
Plunges its roots deep into sleep,
 Far from me, near to me.

Ah, how I desire that your face shall continue to lie across my
throat,
So that I will hear
Through your sleeping mouth,
The delicate pounding of your breast till my dying day.

Jean Cocteau
(translated by Douglas Cooper)

But things could work the other way, as when one afternoon
Picasso wanted to make a drawing of me lying full length, naked,
on the bed. Overcome by sleep, I quite unconsciously pulled the
sheets and blankets over me and disappeared. Poor Picasso,
cheated thus of his model, had not the courage to wake me but
patiently waited till I opened my eyes again before carrying on
with his drawing.

So, on the Sunday in question Picasso was back in Paris.
As soon as I arrived at the Rue des Grands Augustins, he pulled
from his pocket a carefully folded handkerchief with a pink
border. 'Do you recognize it? It's the one I used to wipe away
your tears and mine. I'm keeping it.'

At that time, Picasso was seventy. He had also kept – I often
saw it later on in photographs – a real fisherman's jersey, which
I had bought in a shop near Les Lices in St Tropez, which
specialized in such gear and was kept by two old ladies. When he
saw it, Picasso explained to me that one could wash these jerseys
in cold (even salt) water. He seemed to like it so much, although
the size was not right, that I bought it for him. In my turn, I
admired a blue calico jacket with buttons made of wood (it was
1951) which he had bought in Cannes. This made him specially
happy because apparently I was alone in liking it. His immediate
reaction was to get into the white Oldsmobile and tell Marcel
to drive us to Cannes. Picasso had found the jacket in a shop
selling American surplus stock which was on one of the little
streets running between the Rue d'Antibes and the Croisette.
When we left there, I had been fitted out with the same jacket and
a pair of dungarees which were enough to astonish my friends of
St Germain-des-Prés.

29

Picasso got a kick out of the element of surprise in such strange combinations of clothes. Generally speaking, he was indifferent to the way he was dressed. For years, he wore a suit in beige-coloured corduroy, which he had bought at Latreille because the Rue St André-des-Arts is near to the Rue des Grands Augustins. Picasso was in the habit of wiping his hands along the seams of these trousers, but to my amazement – one was often amazed in his company – they never got dirty. In one of the pockets, which was closed with a large safety pin, Picasso kept his keys and a wad of bank notes. I never saw him with a billfold When we went anywhere, in my car, and stopped at a petrol station, he would pull out several notes, amounting to far more than the sum to be paid, and hand them to me saying: 'Were I a gentleman (he pronounced it *jean-te-le-men*), I would pay, rather than you, but you know I'm not very good with money. Be kind and do it for me. You're a clever girl.' The only problem was not to be given more notes than were necessary. Picasso found happiness in making me happy. I think he rediscovered the simplicity of his youth in being able to gratify the wishes of the woman he loved, because he had not had a chance since about the age of twenty. Money meant nothing to him. He knew the value of his paintings, but as it was many years since he himself had paid for what he bought, he was unaware of what things cost.

Picasso's unconcern shocked his dear friend Eluard, who one day undertook 'to re-educate him'. Eluard, who had never had as much money as he needed, began sending Picasso on little shopping errands. For a few days, he was dispatched each morning with a short list, usually consisting of two or three packets of cigarettes and a box of matches. Eluard then took a sadistic delight in adding to the list two postcards and an envelope or a pencil. Paul took it all very seriously but did not trust Picasso and therefore counted how much money he took out with him. I was forbidden to accompany him, so Picasso went alone. Watching him from the balcony of Eluard's apartment on the Quai de Suffren in St Tropez, we saw him stop in front of the *tabac*, walk towards it and look inside. Timidity getting the upper hand, Picasso first walked away, then, on a sudden impulse, went

inside. We returned to the *salon* and waited for Picasso to arrive. He put on the table everything he had bought and gave us a self-satisfied look. Eluard checked it carefully and then inquired: 'The change?' Picasso, obviously apprehensive of Paul who was looking at him suspiciously, delved into his pocket and put some coins on the table. 'Did you count it?' Paul asked, and Picasso nodded assent. Then came the fatal question: 'How much did you pay out?' Picasso became confused; Paul frowned and exclaimed: 'Once again you've cheated! You haven't counted it at all.' Then appealing to me for support he added: 'He won't ever learn.' Picasso made a great effort and began bombarding us with figures. But it must have been more than twenty years since he last went into a shop on his own, so while he kept on asserting that he had paid 'forty *sous*' or 'three francs fifty' for his cigarettes, we knew that the current prices (in 1951) varied between 30 and 150 francs. He might have felt less confused coping with 'new' francs, but after Eluard I don't suppose anyone made another attempt to 're-educate' him.

Picasso had a sweet revenge on Eluard for these tricks when one day Paul and Dominique, his third wife, were having a domestic row. Eluard's first wife was Gala, who later married Salvador Dali. His second wife, Nusch, had had a painful death which threw Eluard into such a state of depression that his close friends were afraid he might commit suicide. But then, during a trip to Mexico – invited, I think, by a Communist group – Eluard met Dominique, for whom he wrote the poems in *Le Phénix*.

After their marriage, when they lived at St Tropez, Paul and Dominique seemed to be blissfully happy. But Paul had whims and a bad temper like some spoilt child, which the masterful Dominique treated with disdain. Paul was given to sulking on such occasions and would refuse to go to the Pampelonne beach, where in those days there were very few people, or to the Salins, where there was nobody.

One day, Picasso and I arrived at Eluard's apartment and found Paul, to our surprise, in a towering rage. He was in the habit of wearing all summer a pair of workman's dungarees,

31

with shoulder straps, and a pale blue shirt. The flow of epithets directed against Dominique, who was apparently out, was in no way interrupted by our arrival; quite the contrary. Picasso, amazed, asked Eluard what was wrong. 'The trollop has gone off with my money.'

'Who?'

'Dominique! I put my money in my pocket (he was desperately searching in his two side pockets). We had a row this morning and I told her I was going back to Paris, would get blind drunk, and didn't need her around. So she left for the beach, and when I went to get my money to buy myself a railroad ticket, I found she had taken it.'

Picasso tried to soothe him, though inwardly he was gloating. 'She'll give it back.'

Paul answered: 'Of course she'll give it back, but in the meanwhile I can't leave. Can you lend me some money for my journey?'

Picasso hesitated, looked at me and I indicated, as discreetly as possible, that he should do nothing. He played for time: 'Are you sure she's taken it?'

Eluard exploded: 'I know what I've got, don't I? It was in my pocket. Look for yourself. They're empty.' With a defiant gesture, he turned his pockets inside out. At that moment, the clock struck twelve. I tried to change the subject: 'And supposing, Paul, you went off to lunch with us? You can't leave, anyway, before the late afternoon because there is no train.'

Picasso seized his chance: 'Yes, come and eat a crayfish with us.'

Paul hesitated, calmed down and finally accepted our invitation, with the result that a few minutes later we were all seated on the terrace of L'Escale. During lunch, Paul spoke freely about the row and it turned out, as we imagined, not to have been serious. Dominique had opted for the best solution. With the help of crayfish and champagne, Paul recovered himself and became good humoured. When the meal was over, Picasso pulled from his pocket a pencil with leads of different colours, which fascinated Paul. Picasso, much relieved, wanted to try it out. He asked the restaurant to give him a sheet of paper and began to draw a

screech-owl. In a minute, he was showing us what he had done. To tease him, I said, pointing to a corner of the sheet which he had left blank: 'That's still white!' It was true. Picasso put his spectacles on again and filled it in. Eluard, who understood what was going on, pointed to another blank space: 'There's nothing there either.' Picasso bit his lips and filled the space with some concentric loops.

Just as I was about to point to another empty space, he raised his eyes, saw us smiling, realized the game we were playing and set about filling in every spot of white which was still visible. When the entire sheet was covered, he passed it over and we saw a marvellous mosaic of colours. Picasso looked at Paul and myself facing him across the table, spellbound with admiration. Then looking at each of us in turn, he asked: 'Which of you gets it?'

I saw a shadow of doubt cross Paul's face. Like myself he had experienced such pleasure watching this night-bird come alive that he had forgotten all about his anger and his decision to leave. 'It's for Paul,' I said to Picasso. Pablo took back the drawing and wrote on it: *Elle a dit: Pour Paul** and handed it to Eluard, who left us with a broad smile on his face.

Hardly was he out of earshot than Picasso said: 'Why did you give it to him? I made it for you.'

'I know, Pablo, but he wanted it so much, and now he's happy.'

After Eluard's death, Dominique, considerate as always, gave me this drawing because she felt that it had always been mine by right. I was greatly touched to be reunited with this owl, in the depths of whose eyes lurked so many fond memories.

But to go on with the story of the unfortunate episode which gave rise to this drawing, we found Paul next day very shame-faced. The money which he had accused Dominique of filching from him had been all the time in the upper pocket of his dungarees, where of course he had not looked.

As Paul didn't want to go with us to the Salins beach, because he had some work to finish, we went alone. When we got back into town, Picasso wanted an ice cream, so we sat down outside

* She says: For Paul.

33

Sénéquier's *pâtisserie*, where there was the usual afternoon bustle. It was very hot, the ice cream was deliciously cold, and we sat quietly watching the summer visitors go by. Suddenly, Picasso became restless: 'Hide . . . quickly . . . I don't want her to see us.' I stared open-eyed.

'Who?'

'Her! Don't you see her?'

I didn't see anyone I knew. Picasso moved his chair so as to be concealed. He seemed annoyed by my bewilderment.

'Look at her there between her two pederasts . . . in front of you. Carrying a little basket.'

There indeed I saw a rather ugly woman, dressed in black, carrying a wicker basket in the crook of her arm in an affected manner. 'Sorry, but I'm sure I've never seen her before.'

'It's Marie-Laure. If she sees us, we'll never get rid of her.'

I guessed he meant Marie-Laure de Noailles, who was scanning the crowded terrace of Sénéquier in search of someone she knew. Eventually she left, having overlooked Picasso who calmed down and relaxed again.

'You know, I hate her. I've told her so, but she won't believe me. She's always so badly dressed that the *couturiers* vie with each other in refusing her custom. It's appalling. She's a counter-advertisement.' His equanimity returned after he had requited his fear with a malicious remark. Picasso was gay and laughed freely. I must have reacted as he hoped because he went on in the same vein: 'What's more, she's always very dirty.'

Time passed, then Paul and Dominique Eluard joined us and were told by Picasso how he had escaped 'from the clutches of Marie-Laure'. To which Dominique replied: 'We're going over to stay with her at Hyères in the next few days. She's invited Paul, and this will be our honeymoon.'

Paul, delighted, went on: 'We're having difficulty with Caroline (Dominique's daughter by her previous marriage, aged seven). She won't stop crying, because she wants to come with us, and Dominique is having a hard time persuading her that you don't go with your parents on their honeymoon.'

Paul's memory had been stirred by the mention of the name

34

Noailles and he continued: 'Charles de Noailles, her husband, thought of himself as a patron of the arts. In the Surrealist days we launched a review called *Minotaure*, for which the subscription rate was very low – thirty francs per year. One day Charles wrote me a letter of several pages to explain that he was cancelling his subscription because they were penniless. Just think . . . thirty francs!'

After that, Picasso and Paul lapsed into silence.

...

A few weeks later, when we were all back in Paris, the presentation of the film *Los Olvidados* (*The Forgotten Ones*) was announced. Picasso wanted to see what his friend Buñuel had produced, but even though Buñuel had come back into the everyday world, after years spent on experimental work, this film in a new style was still not acceptable for a public showing. Therefore when Langlois, the director of the Cinémathèque in the Avenue de Messine offered to arrange a private showing for him, Picasso accepted happily. Langlois met Picasso, Sabartès and myself at the door of the projection room and then disappeared.

The feature film was preceded by a short, the subject of which I have forgotten. While this was being shown, the door behind us was opened and Langlois showed in a lady and gentleman. Picasso threw a quick glance over his shoulder and, obviously annoyed, shrank into his seat. When the first film was over, the lights were turned on. The lady behind us got up and came over to embrace Picasso, who ostensibly drew back. It was Marie-Laure de Noailles, who (as Picasso maintained later) must have been told in advance by Langlois. She turned a blind eye on Picasso's anger and evasiveness, but did not venture to move from the row she was in. Picasso, who was sitting between Sabartès and myself, turned to me, his face white with suppressed rage, and exclaimed in a loud voice: 'You asked me once why I am a Communist. Well, I'm a Communist to see that people like Marie-Laure de Noailles are hanged.'

She could not have failed to hear what he said, though she

showed no sign of it. Nevertheless she slipped away quickly at the end of the film. Picasso, calm by then, but cross with Langlois none the less for having trapped him, suggested to Sabartès and myself that we should go and have a drink in a café.

He was in a bad mood, and showed it in his criticism of the film. Referring to the scene where children maltreat a blind man he sneered: 'Anyway, children don't interest me, nor the problems they raise. I don't have to solve them.' He sipped his drink and carried on: 'Terror being spread by children ... it's too elementary. I'm much more frightened of a man drinking a glass of beer on the terrace of a café.'

We found Marcel and the Oldsmobile, took Sabartès to his home and then got out on the Quai des Grands Augustins. Pablo said he wanted to walk a bit. We walked up the Rue Dauphine, passing Le Tabou.[20]

'I was one of the first, you know, to put it on the map. When it opened, it was run by Annette, who is now the wife of Giacometti.'

A little further on we passed the restaurant Le Catalan,[21] which prompted further memories. Once back in the studio, Picasso returned to the problem of children, with which he seemed to be much preoccupied, no matter what he might say.

'You see, getting a woman with child is for me taking possession, and helps to kill whatever feelings existed. You can't imagine how constantly I feel the need to free myself.'

Somewhat timidly I asked: 'And Françoise Gilot?'[22]

'Well, I didn't want children. But she did.'

'Why?'

I saw Picasso beginning to fidget. 'I don't know. She thought it was the right thing to do. But you know I always made her look after them and refused to employ a servant.'

This was true. At Vallauris, they only employed a cleaning woman who came in daily. Dominique Eluard, who was fond of Françoise, told me that after he had finished his daily bathe on the beach at Golfe-Juan, Picasso would go home in the car, leaving Françoise to bring the children back by bus.

Picasso stayed silent for a few moments, thinking. Then

he looked at me with misgiving, as was his wont when preparing to say something serious which he knew would be thought scandalous or paradoxical and added: 'Do you know, I couldn't sleep with a woman who had had a child by another man. I would have feelings of disgust.'[23]

Another time, when he gave me a portrait of myself which he had done while we were separated, he remarked: 'We didn't want children, but we've got one all the same. It has been produced by you and me, yet it is neither you nor me, and it has a life of its own. When I make a drawing of you, I always want to make an animal of you. Yet sometimes it's a little girl and sometimes a woman. That's why drawing is a serious matter.'

Picasso rarely discussed his own art, and when he did so was even more shy than when talking about his emotions. 'With you I can say anything; I can be natural and don't have to wear a mask. We speak the same language. But when I'm with several people, I have to act as interpreter. I have to translate one thing into several languages, and it's exhausting. Afterwards it's so difficult to find myself again.'

I was granted the privilege of watching Picasso while he worked. When he made a drawing or an engraving of myself, we both sat at the same big table. He would put on his spectacles, sit facing me, pass over paper and pencils and say: 'Start to draw, anything you like ... it doesn't matter. The most important thing is that you are there.' From time to time, we fought over the india-rubber. In those days I thought I was going to be an artist, and it was always when I was trying to follow various tips he had given me, and so was rubbing out like crazy, that Picasso suddenly wanted to do the same thing.

He would get cross: 'My rubber, where is my rubber?'

Lost in my work, I went on rubbing out. 'Wait a second and I'll give it to you.'

He got impatient: 'You don't need it. Hand it over.' Grudgingly I did so, because I noticed that he didn't really use a rubber all that often. Most of the time he used his own spittle, which he spread with a finger. In fact I own two very pretty wash drawings in which large holes were worn by Picasso applying this technique

37

quite fiercely. And I have another which he started to tear up before I protested, because I thought it pretty. He stopped, surprised, smiled and then softening added: 'Don't cry. I'll stick it together.' And in fact this drawing has a lengthwise tear which is held together by Scotch tape.

Sometimes, at night, Picasso would fetch paintings from his private store-rooms to show me. They were paintings which he had kept and refused to sell, mostly of the 1940 period – women with faces in which the profile, nose and eyes are contorted. He would talk about them in a serious tone, sometimes reflectively, sometimes with a feeling of unease: 'People resent coming to grips with the human face. At the height of his fame, Corot could always sell his landscapes, but no-one wanted his figure pictures.' Picasso looked around his studio where, after dark, the bronze sculptures became a challenging presence: 'My studio is a sort of laboratory, and my experiments are like any others in that they sometimes succeed and sometimes fail. People want everything . . . One really has to be masochistic to like my painting. There are days when I say to myself that all my experiments amount to nothing better than defiling my talent. On occasion my paintings have beauty – at least people see it in them. So much the better. But what matters is how they are created – every line that is added, the transition from one stage to another. That's what painting is about, part poetry, part philosophy.'

Picasso was always secretly worried about one thing: the true value of his own art, and what posterity would say about it. When a new book, entitled *Picasso* like so many others, was added to the growing pile, he would comment sadly on 'the number of stupidities people can write about me . . . People I have never seen take up their pens and write what they know, then send me their book afterwards! One of the truest is Fernande Olivier's *Picasso and his Friends*.[24] I'll give you a copy.'

And he did. It is the only book I have encountered which is written in a spirit of unqualified affection for Picasso.

Eluard's attitude to his own would-be biographers – indeed to biographers in general – was very similar: 'I'm not interested in

38

the private life of an artist unless he is a friend of mine. What do I care whether or not Van Gogh cut off his ear? Anyway, I don't particularly like mankind. I have faith in man: that's different.' This last sentence was the justification Eluard always offered for his membership of the Communist Party.

Paul was no less contemptuous of the innumerable books written about Picasso: 'It's impossible to know exactly what goes on in a man's private life. Everything that's written during our lifetime, in biographies of Picasso or myself, must be full of errors! Even a century after our deaths the real truth may not be known. What, for example, is the truth about the relationship between Picasso and Françoise Gilot? We have no idea. True happiness should be unforced. Love too is shared. They are parallel.'

Fernande Olivier had been Picasso's companion in the *bateau-lavoir* during his years of hardship. But a day came, Picasso confided in me, when he felt he had had enough of her, though he did not know how to end their relationship. Fortunately, another painter living in the *bateau-lavoir* was very much in love with Fernande and wrote her this in a letter. Fernande, whose life was wrapped up in Picasso (of course, he was telling the story!), threw the letter down the lavatory. But the W.C. in the building was a seatless, hole-in-the-floor affair, and the letter was not flushed away. So it fell into the hands of Picasso, who made a terrible, trumped-up scene and put Fernande Olivier out of his studio.

'Didn't you ever see her again?'

'Never'.

But later on she wrote this small book, in which I found repeated many stories which Picasso had told me.

Picasso stayed for a while with Fernande and other friends in Céret (1911)[25]. There – though I don't know how it happened – they acquired a chimpanzee 'as big as a twelve-year-old child', said Picasso. I have already mentioned Picasso's love of animals, but this chimpanzee never could get used to being among such noisy fellows. So he hid behind doors and when any of them – especially Fernande – came into the room, rushed out making

39

ugly grimaces as though he were about to bite them. It became evident that the chimpanzee would have to be got rid of, and then by good fortune a troupe of gipsies arrived in the village. The chimpanzee was offered to them as a present, and they accepted with delight. One gipsy came to fetch the animal, while the rest of the troupe waited with some excitement to see what would befall at the handing-over. The gipsy in question walked into the room, approached the chimpanzee, took it by the hand and led it away quietly like a child going to school, much to the consternation of its former owners.

In the early days in Montmartre, when they were not working, arguing or experimenting, Picasso, Derain, Vlaminck and Braque, with some of their less famous friends, seem to have led a fairly gay night life. Picasso, a short man, always delighted in telling how he and his friends, all of whom were big and strong, commanded respect in Montmartre 'because of our behaviour, our muscles. We were constantly mistaken for boxers. Even taxi drivers would give us – Derain, Braque and myself – a free ride.' He had bought himself a revolver, which he really only used to make a noise. This Picasso talked about gaily: 'People were frightened when I fired a few shots. I knew I wouldn't kill anyone, but it amused me to see how frightened even my friends could be.'

Picasso often referred to this period of his life, and to the extreme poverty in which he and his friends lived, but always in solemn tones: 'I approve of penury. Most people have to go through it. In the days of the Rue Ravignan, we all lived in wretched studios; however I thought that my friends liked them. Yet I observed that as soon as any one of them had earned a little money he moved away. They only wore dirty old clothes because they hadn't enough money to buy new ones . . .' A look of sadness came over Picasso's face: 'Over the years, one gradually loses one's friends. A bohemian life is marvellous, but the bohemianism of one's youth has an end and you can't go back to it – your friends marry, you drift apart.'

'What about you?' I asked nervously. I was thinking of his marriage to Olga, of his fine apartment on the Rue la Boétie,

of his chauffeur, of the Château de Boisgeloup. He read my thoughts.

'I had to earn money, not for myself – you have seen my simple way of living – but for others. Nobody ever thinks about me in the midst of it all. You've no idea how solitary I have always been ... Can you imagine that the Jesuits, who were supposed to teach me something, told my parents, "Have him taught drawing, but don't bother with Latin! He makes drawings all over his exercise books and seems to be interested in nothing else."' Picasso winked. 'Their reputation is not unjustified. They were really very shrewd.

'But before I was sent to the Jesuits I attended a mixed school, where I fell for the bit of "mixture" that sat in front of me.'

'How old were you?'

'Oh, about ten. The "mixture" was very pretty and had lovely curls, of the type then called "English" I think. Well, I became obsessed with the curls of the "mixture" which bobbed up and down in front of me during lessons. And one fine day I brought in a pair of scissors and cut off the "mixture's" curls from behind. She wasn't aware of anything, while I, delighted with myself, concealed my treasure in my satchel. But at the end of the day the mother of the "mixture" nearly threw a fit when she saw what had happened. And I was sent away from the school.'

Picasso laughed as he recalled these episodes from his happy childhood. 'My father, as you know, was a drawing teacher. When I was fourteen, he hired a model for me. Here, look what I did, how polished it is. It might have been done by a seventy-year-old Prix de Rome medallist.' He was right: academic though it was, it was still incredible that a boy of that age could display a technical mastery which usually only results from a lifetime's experience in drawing.

'The models my father hired for me were my reward. After that, I made my whole family pose for me. Then my father handed over to me his brushes and palette. At the time, I didn't understand why. I was too young ... but it made me very happy. It was not until much later that I came to understand the full significance of his gesture.'

'That's to say,' I interjected, 'that he was bowing out before the genius of his son?'

'Well . . . genius is a big word. Yet in a sense . . .'

'But you haven't got a palette.'

'No. You've already seen that my palette is an old newspaper. When I've completely covered one sheet, I tear it off and throw it away. At times I hate to do it, because quite by chance my palette has become a pretty picture. Matisse uses a plate as a palette. Many of my best ideas have come to me fortuitously. You remember how everyone laughed at the bull's head I made with the handlebars and saddle of a bicycle. They were sticking out from a dustbin when they caught my eye – and they were *already* a bull's head. One couldn't help seeing it.'

Much later on, Picasso was to make a monkey's head by sticking together two toy motor cars, one of them upside down. He made a drawing to show me how it was done. The model was a Panhard Dyna, like the car which Dominique Eluard had recently bought to replace her old Renault, whose form had evoked this image for Picasso.

'Of course,' he said, 'it surprises people.' His eyes lit up, he was about to tell a funny story. 'One day, at an exhibition, a woman came up to me and said "Master, I don't understand," to which I replied "That's all that's missing."'

'And she didn't understand even that?'

We both laughed, then Picasso became serious once again. 'Do you remember that when you were a little girl you told me one day that the young did not understand my painting, and I got cross.'

'Of course I remember. You launched into a tirade and said it wasn't a mathematical demonstration.'

The very mention of the word 'understand' was enough to revive his earlier exasperation: 'Do you "understand" the songs of birds . . . or fried potatoes?' Then he calmed down.

'One day, a handful of bristles from my brush got embedded in my painting. So I painted a bird's nest. But, you know, chance really plays only a very small part. One must think, and go on thinking.' Picasso took me over to look at a gouache which was

42

drying, alongside a lithograph made after a painting by Cranach which he greatly admired.[26] The proof was in black ink on white paper. The pose of the figure suggests something between a page and a woman. He began to explain: 'I've always thought of doing a painting with black in the centre and colours all round it. The face would become red and the black would take on a green tinge. Look . . .' He picked up the gouache and held it at arm's length beside the lithograph, which was standing on an easel. His look became serious and he started to talk to himself: 'Painting lives, it moves . . . that's what great painters have known. Then to get green you can either put a red here and a black, or else a green inside the black. And take out the red.' Pablo's face livened up. His nut-brown eyes transfixed the paper as though he were touching it with his look, and I felt unnerved by such intensity. If ever that much-abused word 'genius' had a meaning, it was at moments like this, when Picasso himself and everything which happened to be near him were transformed by a flash of illumination.

'It's the same with forms. Lines diverge or collide. Whereas a square placed beside a diamond-shaped form or a circle produces two very different results.'

Gently, like an autumnal leaf floating silently towards the ground, we descended from the peaks to which he had propelled me. The fire faded from Picasso's eyes and his expression became once more tender, though mischievous.

'If I hadn't become a painter, what would I have been? I don't know how to do anything else.' Then he laughed merrily. Throwing away one cigarette, his fifty-ninth for that day, Pablo lit another and continued his banter: 'The young think it's all right to be doing what I did when I was their age . . . going on the spree, drinking, smoking, sitting in cafés . . . success and fame will seek them out.' He puffed at his cigarette and wrinkled his eyes, thereby emphasizing the two deep furrows which framed his nose and mouth. 'They're wrong. They should be working.'

This reminded him of another tale he told me about his early life in the *bateau-lavoir*. Picasso had discovered an art dealer near

the Place Pigalle who had bought a painting from him for the princely sum of twenty francs![27] 'Next day,' Picasso recalled, adopting a distant and ironic look while his mouth became firmly set, 'I went back with another painting. This Mme Weill bought that one too from me for twenty francs. Of course, my friends and I in the *bateau-lavoir* had a kingly feast and spent it all. So three days later I went back again on foot with a third painting. But when I arrived Mme Weill told me, in a rather disagreeable tone of voice, that she couldn't buy it because she had no more money. You can guess what sort of state I was in when I left. It was snowing. I felt colder than ever. And the very thought of carrying the picture back up the hill of Montmartre was exhausting.' Picasso looked at me hard and I felt all the bitterness and despair of those years flooding back into his mind. Almost in a whisper I put the question: 'What then?'

Picasso raised his eyebrows and with a mocking laugh admitted: 'Then I threw the painting into the gutter – somewhere near the Madeleine. Another winter (1902), when I was living in the Boulevard Voltaire,[28] I burnt a whole series of my own drawings in order to keep warm.' He saw that I was upset by these tales and set about bringing back a smile to my face.

'But sometimes I had a stroke of luck. One day, for instance, I was sick of starving in Paris and wanted to see my family again. So I decided to go back to Spain. But before leaving I deposited a large roll of paintings for safe keeping with two painters, who were then living in a hotel near the Rue de Seine. They threw the roll on top of the wardrobe in their room. A few months later, when I returned from Spain, I went to look for my friends . . . and my paintings. But they had moved . . . and forgotten all about the roll on top of the wardrobe. In a state of despair, I went back to their former hotel, and there I found my roll of paintings, lying where they had thrown it, covered with a thick layer of dust. You can guess how pleased I was. It's lucky that no one bothers to clean on top of cupboards . . . that justifies my liking for dust.' This was enough to break the tension and I began to laugh.

'All the same,' he said in conclusion, 'I did not have to struggle

to become what I am. But those poor creatures who work against their natural bent and try to emulate me . . . I feel sorry for them.'

The Indian summer has come at last! The dismal rain of the past weeks has given way to a period of unexpected sunshine. The wooded hills are heavy with autumnal odours. A hen pheasant flew off from between the forelegs of my horse, its plumage echoing the golden hue of this autumn afternoon.

This evening, sitting by a crackling fire while my dog sleeps, and listening to the owls screeching and the foxes barking in the moonlight, I cannot believe in my own arithmetic: 1944 from 1972 equals 28. How fast the years go by! Is it really twenty-eight years ago that I first set eyes on Picasso?

When this little man appeared at the door of his studio, I thought I was dreaming. He was dressed in a pale blue coat which set off his tanned complexion, an impressive lock of white hair fell over his lined forehead, while his eyes shone so brightly that they seemed blue. I was so confused and intimidated that I didn't notice the roguishness in his look. His smile was friendly and he was very welcoming. At the time, I was a well-behaved pupil attending the Lycée Fénelon. Paris had been liberated from the Germans only a few weeks previously. Freedom weighed heavy on us. As President of the F.N.E. group in the Lycée I had had a share in starting a broadsheet which, with typical adolescent pomposity, we called *La Voix de Fénelon* (The Voice of Fenelon). As always with this type of publication, it was written by only a few of us. At the Salon d'Automne of that year (1944), some paintings by Picasso which were on view were taken off the walls by a 'Fascist' (I quote!) gang and thrown out of the window. Of course, this aroused our indignation: an article had to be written and Picasso interviewed. On that everyone was agreed. But when a venturesome volunteer was called for, no one raised a hand. Naturally, Picasso was known to us by name only, and had the reputation of being unfriendly to journalists and even of refusing to see them. So my classmates turned to me: 'You are the President, you must go.' Timid but

obstinate, I firmly refused. Several harsh words were exchanged and then we hit on the idea of drawing lots. My name was drawn first. So I promised to go round that very afternoon to Picasso's studio, which was close to the Lycée Fénelon.

I found myself in front of a low building, three sides of which surrounded a courtyard, while the fourth was closed by an iron gate with bars. There was no porter, nor anyone else around. So I took a chance and began to climb a very narrow, rickety staircase. On the first floor, I heard voices coming from the other side of a door. I knocked, and a good-looking, dark-haired young woman opened – I discovered later that she was called Inès – and told me with a smile to go two floors higher. I went on up, hoping against hope that no one would be at home to answer. But, alas, just as I reached the last flight of a staircase which seemed to end in the sky, a door opened and I heard two men exchanging parting words in Spanish. One of them went past me, going down, and I reached the other just as he was about to shut the door.

I had never seen a photograph of Picasso, but this thin little man who faced me with a *béret* on his head, a pointed nose, spectacles which did not conceal the vivacity of his eyes and a scowl, fitted my conception of what the painter would look like. On an impulse, and taking my courage in both hands, I announced that I was a schoolgirl, member of the f.n.e., that the school's broadsheet, etc. . . . and that I had come to interview him. I got to the end, breathless, aware that I had flushed crimson, and waited. The man I had spoken to, listened in silence, invited me inside, shut the door after us and said: 'I am not Picasso.' Collapse of schoolgirl! Was I on the wrong floor? Cross and dismayed, I was retreating towards the door thinking to myself that I would never try again, when my interlocutor said quickly: 'But come back tomorrow at midday and you'll see him.' I looked at him aghast and for the first time he smiled. And that is how I began a long friendship with Sabartès which only ended with his death some twenty years later.

Sabartès, a Catalan, was a friend of Picasso's youth. He was a

poet and one of the group of painters and writers who shuttled between Barcelona and Paris. Picasso was greatly attached to him and painted him in a variety of guises – from a dreamy, expectant young man seated at a café-table, looking a bit like Verlaine, to a faun or satyr partaking in the Antipolis routs of 1947–8.[29] Sabartès' friendship for Picasso had its ups and downs. In particular, he could never understand why Picasso needed so many women in his life and regarded these companions with a mixture of distrust and scorn. Picasso's story was that Sabartès had escaped from his family in Barcelona, while he was still young, to travel and see the world, especially South America. In the days when I knew him, Sabartès was married to a white-haired Spanish woman, who was charming, devoted and capable of inducing a warm ambience even in one of those soulless, red brick buildings of the Rue de la Convention, which somehow reminded me of the home of Paul and Nusch Eluard in La Chapelle. Perhaps the quantity of drawings and paintings by Picasso on the walls had something to do with it. All his life, Sabartès was a devoted friend to Picasso, acting latterly as his secretary, occasionally as his confidant and always as his watchdog to ward off the crowd of intruders who daily climbed up the winding staircase in the Rue des Grands Augustins.

Dominique Eluard, who had no liking for Sabartès and not much for Picasso, once said to me: 'Paul has no money and cannot afford a Sabartès, a Marcel and an Inès, who form a small private court. He has no protection against success.' After which, Eluard, correcting and amplifying, said: 'Picasso has around him a small court of admirers. Sometimes one has to argue with him, and he doesn't mind being contradicted.' Then Paul added: 'Picasso needs to be argued with. Or more exactly, he likes to be faced with a truth which he recognizes but will not state of his own accord, because he enjoys being capricious and paradoxical. He may hold it against you at the actual moment, yet later on he's grateful.'

Sabartès was never able to fulfil himself as a poet and ended by putting his literary talent at the service of Picasso. He wrote in Spanish and used to ask me to translate the prefaces and essays

devoted to 'Picasso as a Printmaker' or 'Picasso as a Ceramist' which he wrote for different publishers. So I spent afternoons in his apartment working with him, word by word, on these texts, while Mme Sarbartès sat near the window sewing or knitting. I loved these long afternoon sessions, which were interrupted with comments on the work of Picasso and his attitude towards basic materials – clay for example – or technical processes. Sabartès explained to me in detail the various engraving techniques – etching, lithography, dry-point and so on. Yet he never said a word about Picasso as a man, or about their youth.

Sabartès once wrote a novel entitled *Son Excellence* (*His Excellency*), the hero of which was a South American dictator. He asked me to translate it into French and it was published by Editeurs Français Réunis. I was greatly touched by this display of confidence because Sabartès was usually reserved. Not many people read his novel. Nevertheless when I found myself, some years later, reading the novel *Monsieur le Président* by Miguel Angel Asturias, I was struck by certain similarities between the two. I am not suggesting that the one inspired the other. But it struck me then that the 'flop' of Sabartès' novel was undeserved.

Whenever I saw him at the Rue des Grands Augustins, I noticed that he had a sad, somewhat ironical smile, and he would talk to me in a friendly but mocking tone, which he used with real artistry to conceal a genuine affection.

And now to get back to my story. On the day following my first call at Picasso's studio (1944), I returned feeling more sure of myself. Once again Sabartès opened the door and I entered a tiny square hall, with red tiles worn away by people walking over them. Light flooded in from a large window which reached to the floor. A staircase going upwards from this hall was alive with white pigeons. There was also an owl. I had not noticed any of these details on the previous day, but now they were to impress themselves on my memory one by one as my visits became more frequent.

From the other side of a closed door, which I imagined would open into Picasso's studio, came the sound of voices. Sabartès opened this second door and I saw in front of me a long and very

large room. On the right, were a series of tall windows looking on to the courtyard, the Rue des Grands Augustins and the Rue du Pont de Lodi. On the left, some *banderillas* were hanging on the wall. I was so intimidated that I was aware only of a flood of conflicting images, and my embarrassment was not helped by a group of people who stood chatting between the windows and the enormous table which ran almost the whole length of the room. Every head turned to look at me and conversation stopped when I was introduced by Sabartès. I remained near the door. Books were piled up on the table and any titles I could make out seemed to contain the name 'Picasso' in one context or another. Letters, papers and envelopes were scattered around, there were piles of Bristol board, and at the far end of the room a picture stood on an easel. Alongside this was a closed door. I began to wonder which of all the men standing around was Picasso. After my mistake of the day before I was taking no risks. Sabartès realized my predicament and encouraged me, saying: 'Go on in, Picasso will receive you at once.' I took a step forward, holding my briefcase, with the last number of *La Voix de Fénelon* inside it, at arm's length. Suddenly I woke up to the brazenness of such behaviour, but it was too late. The door at the far end opened, and a figure appeared showing out a visitor.

'Come on!' Sabartès murmured and I understood that this time it was really 'him'. Sabartès introduced 'the Resistance girl I told you about'. Picasso then took me off into another room, just as big, where the deep silence, after the buzz of conversation in the first room, seemed almost oppressive. As I wandered around, my eye fell on several curious sculptures in bronze, some highly polished, others dark in hue. Picasso obviously read the look of amazement on my face, for he smiled and led me towards a little staircase which I had not noticed because it was hidden behind various objects. Eventually we came to a garden bench on which we sat down, turning our backs to the window. Picasso tried to put me at my ease and appeared to be much amused. Much, much later, he was to explain to me that 'for other reasons' he was every bit as intimidated as the adolescent green-horn who was sitting beside him.

49

I opened my briefcase, fished around inside and finally found my copy of *La Voix de Fénelon*. He said he was delighted to be interviewed by a young girl on behalf of other young girls. I began asking him questions about modern art and this annoyed Picasso. To evoke the whole scene, I propose now to reprint the article I wrote exactly as it appeared at the time in our broadsheet.

IN THE PAINTER'S STUDIO

Phew! Here I am. Having climbed four winding flights of stairs, I am in front of a forbidding door. Suddenly, I have stage-fright. How will 'he' receive me? What shall I say to 'him'? Obviously I have taken on more than my courage will stand, and I start to go down again. But it is too late. Just as I am turning away the staircase is flooded with light: the door has opened. Turning round again quickly, I ask with some embarrassment to be admitted to the sanctuary. Then I start on a tour of paintings in a variety of styles and some enormous sculptures. Finally, having gone a floor higher, I enter the studio ... 'He' is there, luckily, although hidden from me by an enormous canvas.

Now I have to go forward, it is too late to run away. Suddenly I find myself confronted by two outstretched hands, a smile of amusement, and a suntanned face, illuminated by two lively eyes and softened by silver-grey hair. This is Picasso.

The welcome restored my courage and I was able to launch into a conversation about Fénelon, its life, its activities, its broadsheet. This was a means of putting off the moment when I will have to ask the burning question which accounts for my presence here, but which I dare not put into words. For how am I to confess to Picasso that the young, who are ready to combat prejudice and are excited by anything new, original and dynamic, are rather perplexed by his paintings? Some of them even go as far in their disapproval as the old fuddy-duddies who sit up nights looking at everything they are shown under the microscope in order to compare it with what they call 'reality'. Yet I have to ask 'him' this terrible question. We must clear up the misunderstanding between us before we can refute the falsehood, spread around by those who, while claiming to be impartial, feel nothing and cherish their own prejudice that Picasso is laughing

at the public. In the meanwhile he shows me, with good grace, several drawings, studies of women done in Indian ink, his latest paintings – in particular, the confrontation of a cock, orange and red, and a blue dove, in the pink and purple light of dawning day[30] – and some reproductions of much earlier works. While we were looking at these reproductions, I took the plunge and uttered the terrible words: 'I don't understand . . .'

Before I realized what I was doing, a storm had broken over my head. Picasso was cross: 'Understand! That's just it! Since when has a painting been a mathematical demonstration? Paintings aren't supposed to explain (explain what, I wondered!) but to inspire emotions in the heart of whoever looks at them. A work of art should not leave a man indifferent. He should not be able to walk past it casting only a careless glance . . .'

(On this score, I don't think Picasso has anything to worry about. People don't cast either rapid or indifferent glances at his paintings.)

'He should react, experience a thrill, create in his turn, if not actually at least in imagination . . .

'The artist must rouse the spectator from his torpor, shake him, catch him by the throat and force him to become aware of the world in which he is living. But to achieve that, one has to take him outside of it . . .'

I bowed before the storm which, by this time, had begun to abate. However, I had been successful – and it is said to be very difficult – in getting Picasso to offer some explanation of himself and his work.

But he had not finished: 'There is a fundamental misunderstanding today between the artist and his fellow men. Too many people cling to old-fashioned notions such as, for example, that a picture should only represent something "beautiful". That's a strange limitation to try and impose. And I'm not taking into consideration the relative aspects of this "beauty" they talk about, which is made up of conventions, period, place, education, age, personal taste and so on. Art, no matter of what kind, should oblige a man to commit himself wholly, to give himself without reservations. "Beauty" is naturally one of the means, one of the emotions by which one can achieve this aim, but it is not the only one. Above all, one must not leave the soul

undisturbed, because if it stagnates a sediment forms. Mud is inert, whereas a raging torrent is limpid and pure. In literature, you accept the "realist" novel, don't you? Well, there it is not conventional "beauty" that is presented as having artistic worth, so to be consistent should you not reject anything which exposes the ugliness of life: Balzac, Zola and – rather nearer our time – Henri Troyat (L'Araigne comes to mind)?[31] Can't you realize that there is beauty in ugliness? Why deny to painting what you accept in literature? Why exclude your heart and senses from what you accept with your mind?

'Don't you think that a painter who can arouse a feeling of greatness in a man has done something more worthwhile than making an aesthete of him? First and foremost, keep your imagination alive. It is a gift of youth which is all too quickly lost. Allow me then to help you preserve this most precious faculty, a faculty which enables one to turn a saddle and a pair of handlebars into a bull's head, or a glimpse of the sky between two roof tops into an azure infinity ...'

Picasso's smile as he pronounced these final words was unforgettable, and I am comforted by the discovery of a man who has faith in the young, is ready to give the best of himself for them and hopes to endow our present unbalanced – not to say inchoate – civilization with a sense of true beauty, the beauty of a great soul.

Gilles

When we went back downstairs, Picasso asked me, as though nothing had happened, when my article would appear and said I should bring it round for him to read. 'Telephone Sabartès. He'll tell you when you can come.' After the bawling out which I had just received, there seemed no reason to believe that Picasso would ever see me again, neither myself nor any other schoolgirl who didn't know about the subject. So my surprise and delight were as great as the silence with which I let this remark pass. Once again I had flushed crimson. I had a tendency to blush which Picasso, in his glee, was to remind me of on many future occasions. We went back into the first room where other visitors were waiting to be received. A hush fell, followed by a complete silence when Picasso asked Sabartès to give me his telephone number, that Odéon 28–44 which I was to dial so often in the future.

It took a while to compose my masterpiece, and then the new number of the broadsheet was ready to be printed. After this, I telephoned, for I had gained in self-confidence through the admiration and envy of my classmates. Sabartès went to ask Picasso when he could see me, and a new meeting was arranged for the following Wednesday at 4 pm.

There was no risk of my being late. Five minutes early and holding my breath, I rang the bell. There was a heavy silence. Then I heard someone coming down the inside staircase. The door opened, and it was Picasso himself who admitted me. He was alone. He took me into the first room – I was beginning to learn the ritual – then into the second, where we sat on the bench. But I couldn't bring myself to get out the broadsheet, which of course was in my briefcase. I had already begun to realize that anything one could write or say about Picasso was inevitably incomplete, distorted, and wide of the mark in relation to the wholly exceptional human being which I then, and for ever afterwards, felt him to be. In his generosity, Picasso too did not mention the article.

I left with the unmentioned broadsheet still in my briefcase and a bar of American chocolate in my hand. About once a week, officers of the Allied armies would ask permission to visit Picasso in his studio, and when they left they would offer him some chocolate, a precious commodity in that autumn of 1944. As I did not dare mention painting to him again, I found myself saying that I liked chocolate. 'Wait a minute!' interjected Picasso. He went off and came back a few seconds later bearing this present. Picasso's chocolate – what a fabulous taste it had in the aftermath of the Occupation! Picasso encouraged me to talk, the chocolate helped loosen my tongue and my chatter amused him. That's how we came to arrange a third meeting for the following Wednesday at the same time. 'Ring twice' Picasso impressed on me, 'because I only receive in the morning. Sabartès keeps watch on the door. In the afternoon I work, and don't let anyone in.'

Only now can I fully appreciate the great sacrifice that Picasso made in taking time off to talk to me instead of working, which

was one of his main reasons for living. I remember what he said when he told me about his father handing over his palette and brushes: 'I didn't understand until much later.' Nor had I understood, but you cannot put the clock back.

So I was invited to the studio every Wednesday. Then winter came. The studio was not heated, except for the upper floor. I used to hear him coming down from upstairs to open the door and I began to be curious about this other floor. One cold, grey afternoon in November, Picasso led me there up the other small staircase. Upstairs, under the eaves, I found another immense studio, adjoining two small rooms and a bathroom lit by transoms. The first room contained only a few pieces of furniture, while in the second – heated by a large coal-burning stove whose stove-pipes ran across the room – was his bed, covered with a splendid white bull's hide with dark spots, a chest-of-drawers and a rocking-chair. The floor was again made of much-worn red tiles. I seem to remember too a sort of heavy string mat. That was the degree of austerity in which Picasso lived. How could I disbelieve him, therefore, when he used to say to me: 'When I was young and saw painters who had "made it"' – an ironical smile crossed his face as he spoke – 'I used to say to myself that I never wanted to be one of those whose photograph appears every day in all the newspapers. I didn't want celebrity. I am too fond of hardship. That's why I have painted heads with their noses put on crooked. Just to disgust people! But nothing doing! They have found them "beautiful" – though the most attractive are sometimes the most terrible, if only they could see.' I felt sure that he was deeply convinced of this.

To all intents and purposes, most journalists and photographers (except close friends like Man Ray) were no more aware than was the general public of what Picasso looked like until the mid-1950s. So although he was already world-famous, Picasso and I were able to spend the summer quietly together at St Tropez in 1951 in comparative anonymity. Even when we travelled together and Picasso himself went to the desk in a hotel to get us a room, the immediate reaction of the duty clerk on seeing his none too

elegant clothes – Picasso didn't care – was, more often than not, to say that he had none available.

Sometimes, for instance at the Hôtel de L'Aigle Noir in Fontainebleau, Marcel, our devoted chauffeur, would arrange to leave the white Oldsmobile in full view in front of the entrance. When Picasso and I went inside – with my black trousers and pullover or shirt of the same colour, I looked really no better – we were met with suspicious stares. Then we were handed our registration slips to fill in, after which it was fun to observe an expression of amazement and incredulity cross the booking clerk's face. Picasso watched with relish the working of his mind as he took in the Oldsmobile, then himself, and next asked nervously 'Have you an identity card?' Picasso said that at that moment he always wanted to bring out his Party card: 'Comrade Picasso'. Bowings and scrapings followed, and a request to sign the book of famous guests.

At the Hôtel du Bas-Bréau in Barbizon, we had a different experience. We had gone there for a weekend, the reservation having been made in my name. On Sunday at midday, all the tables in the garden were taken for lunch. Picasso and I were still in the same clothes: he in the beige velvet corduroy suit from Latreille, myself in black trousers from St Germain-des-Prés. Few women wore these in 1950, except in select places, and certainly not the well-to-do ladies who frequented the Bas-Bréau. Picasso and I were shown to a table next to two elderly couples. One of the women at this table, whose corpulence was impressive, was also wearing an enormous and vastly over-decorated hat. When they saw us arriving, they looked us up and down contemptuously, screwed up their mouths and would, I am sure, have pushed their chairs farther away if they could, for fear of catching fleas.

Pablo and I both noticed the look of disapproval on the faces of our neighbours, and that gave us something to joke about. Suddenly Picasso, who was facing the entrance, exclaimed: 'Look there's Jean Marais!' Indeed it was 'Jeannot', very elegantly dressed and wearing a light-coloured shirt open at the neck with a red silk scarf. He was followed by five or six young men.

Picasso's comment was: 'Look, he's accompanied by half a dozen little Jean Marais.' Jean, following the *maître d'hôtel*, walked across the garden towards a table near ours. He had to pass right beside us, but pretended not to notice and walked ahead with a charming unconcern. Having passed the neighbouring table, where the woman in a hat could not take her eyes off him, he drew level with Picasso, who in his Spanish accent simply said: 'Jeannot!'

Marais lowered his eyes and saw Pablo, at which point his face lit up. He leant over, Picasso got up, and they embraced each other warmly. The 'hat' and her friends at table were nonplussed. Picasso introduced me, much to my delight. Jean Marais! How envious all my friends would be when I told them about the meeting. Pablo's first question was: 'How's Jean?' (The reference was, of course, to Cocteau, who I had not yet met.) Gradually the truth began to dawn on our neighbours. As they listened to Jean Marais' questions and heard Pablo's accent they became more and more certain of who we were. They started to talk in loud voices about Toulouse-Lautrec, then the two women strained their necks in our direction and tried to smile. Picasso was amused by the episode, but that evening when we got back to Paris he picked up one of his illustrated books and added a second series of illustrations. Having covered all the blank pages with drawings, he gave it to me, and on the strength of these I named him in jest 'Picasso Pornographer'. He was overjoyed, and often used to talk of 'the lady of Barbizon'.

Generally speaking, Picasso did not enjoy being with painters. He regarded most of them as having neither talent nor originality and would accuse even the greatest of copying him. Not even the painting of Françoise Gilot escaped censure. After one of her exhibitions, Picasso said in a condescending and somewhat grating tone of voice: 'What she does is all white, it's enamelled like a kitchen.'

He was more tolerant with amateurs like Jean Marais. On the occasion of our lunchtime meeting, Pablo had inquired about his painting and Jean, touched by his interest, said regretfully that he worked very slowly. When we were alone again, Picasso

said to me: 'You know, what he does is rather pretty.' And he meant it. But Picasso didn't encourage for long my own attempts at painting. I once showed him a canvas with which I was specially pleased, and his comment put me off for ever: 'If it amuses you to paint, carry on . . . have fun!' These few words, accompanied by a quizzical smile, killed my career as a painter. Instead at Barbizon I embarked on a film career.

Among the topics of conversation between Pablo and Marais was the film *Nez de cuir* (*Leather Nose*) which was going to be made by Yves Allégret. Two or three small parts still remained to be filled before shooting began. One of these was for a girl who could ride a horse. I pricked up my ears but said nothing. Picasso did it for me: 'Why don't you introduce Geneviève to Allégret? He's a friend of mine you know.'

Jean Marais looked at me: 'Can you ride?' Overawed by the idea of talking to Jean Marais, I replied timidly that I had been put on a horse some years previously by cowboys in Colorado, that after that I had taken some lessons, and so long as I wasn't asked to do *haute école* I thought . . . Marais broke in quickly: 'Not at all. They are hunting scenes. You would have to ride side-saddle, be able to gallop and not be frightened of horses.'

Then Marais turned to Picasso: 'Allégret's former wife, Simone Signoret, is petrified of horses. This has left Yves with a deep-seated conviction that all actresses are like that.'

We made a date for the next day at the studios. Marcel drove me there in the Oldsmobile and Marais introduced me to Allégret. His first question was: 'You're not frightened of horses, are you?' He was reassured when I laughed.

Ten minutes later, barely understanding what had happened, I left the studios with a contract worth five thousand francs a day (in 1951) for fifteen days of shooting, most of them to be spent on horseback in the forest of Rambouillet. Picasso was delighted when I got back and triumphantly produced my contract. Immediately he started to declaim: 'Poor earthworm, I, in love with a star!'

Then he straddled a chair and asked me to recite for him the

scene between Ruy Blas and Don Salluste which he loved. 'You know: *Une marquise disait à l'église . . .*'

I protested: 'You've left out several feet of verse.'

Pablo laughed, and added: All right, you speak it.'

Une marquise
Me disait l'autre jour en sortant de l'église:
Quel est donc ce brigand . . .

I was bored, because I had had to go through the scene for him so many times already. Picasso showed the same persistence when he was copying one of his own poems, and I had laughingly remarked that he was better at drawing than spelling. For the various copies that he made of this poem all contained exactly the same spelling mistakes, though he'd insisted on my correcting them for him in the first draft.

My new career provided me with some idyllic days. I was driven out in the morning by Marcel and came home in the evening in Jean Marais' open sports car, often accompanied by Valentine Tessier and Denis d'Inès, who were fine actors and charming people.

One evening, Jean Marais and I were going to have dinner with Picasso. Marais finished his work for the day at about three o'clock in the afternoon and came to tell me that he was leaving. As the scene being shot was a ball in a *château*, I modestly concluded that my presence on the lot was not indispensable. So I took off my make-up quickly and went to fetch my pay-packet for the day, which Marais persuaded the cashier to give me right away.

Well, that was the very afternoon for which *my* scene with Valentine Tessier had been scheduled. They looked for me everywhere, but in vain. Finally, someone said I had been seen going off with Jean Marais, which created quite a sensation. The producer – who maybe hoped to enjoy the same privilege – sent me a telegram, which I found when I got home, informing me in no uncertain terms that I need never again show up at the studio.

There was consternation next day in the Rue des Grands Augustins, but Picasso was quick to draw a moral from the story: 'There you are – you begin a career under the aegis of Picasso

and it is terminated through the fault of Jean Marais. How many women can claim as much?' This formulation was enough to console me and once again, without too many pangs, I abandoned a career.

I had never shown Picasso any of my own poems, but one day I plucked up the courage to tell him that I did occasionally write poetry. This pleased him and he reminded me of the literary background to our first meeting.

But he did not ask me to show him any of my poems and, as I was not at all sure of my gifts in this field, they remained shut away in a drawer. I should have known that it was best to say nothing after listening to Eluard during our summer holiday in St Tropez: 'When a young poet asks me if he should go on writing, I always want to answer "No". For if he is really a poet, he will carry on no matter what one tells him. Each of us knows instinctively whether what he has done is any good. Each of us is his own best critic . . .' After which, I heard Picasso say: 'If only one could write badly! Nowadays writers simply move words around a bit and continue to respect syntax. What one needs is a perfect knowledge of semantics and an ability to write badly.'

That of course is what he had attempted in his play *Le Désir attrapé par la queue* (*Desire Caught by the Tail*)[32] in which the characters are called Tart, Onion and the like. A reading of the play was given in English during a Picasso exhibition in London in 1950. Picasso went once to London about this time for a Peace Congress, and when I asked him what impression it had made on him, he replied with a complimentary remark about his chauffeur: 'Do you know, when Marcel arrived he drove on the left as if he had always done so.'[33]

And I could not get another word out of Picasso on the subject, apart from the statement that Roland Penrose had married, as his second wife, Lee Miller, who had had a part in Cocteau's first film *Le Sang d'un poète* (*Blood of a Poet*).

Eluard, unlike Picasso, spoke very little about his childhood. Indeed as a rule he never mentioned it. Great was my surprise, therefore, when I once heard him refer to his mother. We were lying on the beach, one afternoon in July, and Paul had just come

out of the sea. He was wrapped in a scarlet bath-robe and his tall silhouette stood out black against the deep blue sky. For no apparent reason, he informed me that his real name was Grindel, and that he had been born in Normandy. 'I never succeeded in astonishing my mother. When I showed her my own books, or flattering articles about myself, she would read them without showing any emotion, then hand the magazine back with a shrug of incomprehension, screw up her mouth and in all sincerity say: 'I can't imagine what all those people see in you which is so extraordinary.'

In my humble way, I too had to bear with a mother of similar outlook. But one day things changed when Picasso came to see me – I was sick and in bed – and they met. Picasso, with an air of great mystery (I recognized the sign of confidence!), pulled out his spectacle case and showed my mother a photograph of Paloma. My mother fetched a photograph of myself also aged about three, and the two of them sat there comparing their little photographs and exchanging remarks about children, for in my mother's eyes I remained a child until her death.

A few years later I told this story to Jean Cocteau, who was no less amused than myself and recalled the circumstances in which Diaghilev had said to him, in the Place de la Concorde: 'Jean, astonish me!'

'You see,' Cocteau added, 'what he really ought to have said was "Above all, astonish your mother!"'

Cocteau had also never forgotten another of Diaghilev's conceits: 'Get rid of what is ridiculous about your name.' Jean, who always became a bit dreamy when talking about this period of his youth, was quick to add: 'Is any name more ridiculous than Picasso, Radiguet or Cocteau? All names are ridiculous. Think of the nick-names children use at school.'

I liked visiting Cocteau in his charming house at Milly on Mondays, because the crowd of visitors on a Sunday was too much for me. On one such occasion, he showed me a school note-book of which he was turning the pages affectionately. It was the manuscript of *Le Bal du Comte d'Orgel*.[34]

I was fascinated by the large room in which he worked and

received friends, by the many objects with which he surrounded himself, including a wooden horse from a roundabout, and by the enormous fireplace which was deep enough to take a whole tree trunk. A staircase went up from this *salon* to the bedrooms. Upstairs there was also a large studio which he showed me one day. There I found the floor covered with drawings done in chalks or gouache on large sheets of paper, in a variety of colours – though pale blue and black predominated. Harlequins and portraits were scattered around, forming an evocative mosaic.

On a particular January morning I arrived, entered the *salon* and was greeted by Cocteau's voice from above summoning me upstairs. He was shaving in the bathroom and offered me a linen-basket to sit on. He then told me, with a lot of enthusiasm, about the calls he was making on Academicians to present his own candidature for the Académie Française.

'Do you realize,' – his face was covered with soap, but he stopped shaving and, brush in hand, mimed the scene – 'that they're adorable old gentlemen! Yesterday I called on the Duc de Broglie ... all of a sudden, he began to wiggle his hands ... like that. I thought he was doing a marionette show for me, as though I were a child. So to keep him happy, I did the same thing.' Jean burst out laughing, looked at me and went on: 'You know what he was really doing? He was explaining the quantum theory to me.'

Picasso as well as Cocteau believed in magic – especially verbal magic, words to use and others to avoid. For Picasso, the one forbidden word which, if pronounced, put him in a fearful rage was 'death'. It is hard for a young person talking to someone almost fifty years older than herself, to avoid using an expression like 'at your age ...' But I soon learnt to my cost that, in this one respect, I had constantly to watch what I was saying. On the other hand, we could talk for hours – many times I saw dawn rise in the Rue des Grands Augustins after a night-long discussion about all sorts of things – about, for example, the possibility of a life after death, in which as it happens Picasso believed. In my opinion, this belief was intimately allied to his perpetual self-questioning on the worth of his own art: what he had achieved

with it, what would happen to his works (in after-years, therefore) and how he would be judged by posterity. On this score, Picasso was a man tortured in turn by doubt and hope.

It was all right for me to refer playfully to some little discovery Picasso had just made as 'an idea of genius'. But when the idea of *real genius* was involved, he stopped laughing, a pained look came over his face, the folds and crevices in his skin became accentuated and the blaze in his eyes dimmed.

Our life together day after day, even though that part which we shared was almost ideal, dulled somewhat my awareness of how much I admired him. From time to time, when I was abruptly faced with some of his works, I was spellbound, as though in the presence of something which the Greeks called 'divine'. Agitated and confused, I tried to explain. My efforts were clumsy because I was seized by fear and trembling, though instinct told me that Picasso was experiencing the same fears while humbly accepting his fate as a genius. His only link with the solid world of mortals took the form of laughter ... or love.

It is easier to tell about laughter. At night, I liked to drink a cup of coffee, but Picasso did not. We were both incapable of making it, so Inès prepared it in advance. Pablo took particular pleasure in carefully pouring the coffee into a heavy saucepan – the electric cooker was an early model – which he then placed on the hotplate. After a few minutes he would dip his finger in to find out if it was hot enough. If he burnt himself, he made a face and groaned. This was like a ritual. But it was just as much of a ritual for him to laugh when charged with having 'ideas of genius'. And with a mischievous look, he would say in a lighter moment: 'People seem to think I'm tragic. When they come to see me, they have funereal airs and talk about catastrophes. But I like to laugh! You can't imagine what life is like with that poor Françoise who makes a drama out of everything.'

One day, Pablo wanted to take me to the Museé Grimaldi in Antibes. The interior installation had just been completed, though work was still being done on the outside. Pablo asked the Director Monsieur de la Souchère, to let us in on a day it was closed so that

we could be alone, and he received us most graciously. The Museé Grimaldi, standing directly above the ramparts which hold off the sea, has enormous charm. We were the only people in this suite of galleries, where drawings and ceramics, engravings and paintings form a vast complementary ensemble. Stunned by this encounter with a demiurge, and not knowing whether I was more over-whelmed or stimulated by the experience, I turned to observe Picasso. And there stood a small, very small man, whose eye seemed to be caressing each object with immense tenderness. But almost at once an expression of fear flashed across Picasso's face, as if he too felt some tremendous burden placed on his shoulders.

Overwhelmed with emotion, and not a little ashamed of having perhaps been too forgetful in our bantering conversations of the respect which was due to Picasso, I managed to stammer out: 'You ... did you do all that? ...' He had of course already shown me hundreds of drawings, paintings and sculptures, while in New York I had also seen *Guernica* and many other of his works. Yet I had never seen so many in one place at one time, particularly not in the physical presence of the man who had created them, who was himself astonished and a bit frightened by them.

Twenty years later, as I think back, I am still appalled by the clumsiness of my behaviour at that exceptional moment.

Now I must face the more difficult task of outlining that other factor which enabled Picasso to remain earthbound: love. Picasso was so astounded to be assailed by love that he calmly accepted doing no work for hours on end. Humbly, he surrendered to the torrent of fervour by which he was transported. It all began in 1951, after we had been separated for a few years. We had resumed the habit of our afternoon sessions in the Rue des Grands Augus-tins. I had once again taken my place beside the bull's hide in a month of May when, for me, the sun never stopped shining. Yet one day it did and when I suddenly realized that the room, lit only by a transom, was filled with darkness I got up to go. Picasso looked up at the sky. This was not the end of the day, although the sun was obscured by heavy clouds. 'It's going to rain. Wait a little longer,' he advised me. I hesitated, because he had

already given up so much time to me that I felt I ought to go. Then a flash of lightning, followed by a thunder clap and very heavy rain, forced me to sit down again and wait for the storm to pass.

That was the evening Picasso first addressed me as '*tu*', the first time I heard his true voice. Up to that moment, I had been aware of his look, his gestures, his appearance, his talk, all of which were engraved on my memory. But his voice penetrated then to my innermost being, so much so that even today I can hear it with the same clarity. How shall I describe it? Picasso had a foreign accent of course, though his voice was not sing-song. It was often modulated, breaking off suddenly in a flood of laughter or an angry snarl. Tenderness too was in it though it was the tenderness of a wild animal.

I was wholly captivated and happy when I left Picasso later that evening. As soon as I was outside on the pavement, I looked back up at the windows of the studio where darkness reigned. I could make out his form behind the windowpanes, then I saw a light: it was a burning match which turned into the red tip of a lighted cigarette. On the following morning, Picasso told me that he had stood there puffing at his cigarette until he saw me disappear round the corner at the end of the street. And whenever I left at the end of an evening, I could observe this same light behind the window.

One dark night,
 My anguish inflamed by love
– Oh, happy chance! –
 I went out unseen,
My house being now stilled;

In darkness, and secure,
 By the secret ladder, disguised,
– Oh, happy chance! –
 In darkness and concealment,
My house being now stilled;

On that happy night,
 In secret, seen by no-one,
Nor did I look at anything,
 With no other light or guide
Than the one that burned in my heart;

This guided me
 More surely than the light of noon
To where he waited for me
 – Him I knew so well –
In a place where no-one else appeared.

O guiding night!
 O night more lovely than the dawn!
O night that united
 The lover with his beloved,
And transformed the beloved into the Lover.

Upon my flowering breast
 Which I kept wholly for him alone,
There he lay sleeping,
 And I caressing him,
Fanning the air with cedar branches.

When the breeze blew from the battlements
 And parted his hair,
With his gentle hand
 He touched my neck,
And suspended all my senses.

I faltered and forgot myself,
 My face lay upon my beloved,
Everything stopped, I escaped from myself,
 Leaving my cares
Forgotten among the lilies.

<div align="right">

'The Dark Night'
St John of the Cross[35]
(translated by Douglas Cooper)

</div>

The ferns in the dales have been touched by the advent of autumn. The branches of the birch trees and the broom are sleek and wave in the breeze, which, as it parts the branches in the forest lets spots of sunlight fall on the bridle-paths, where the eye is caught by disconsolate mulberry trees. Even the does' pelts are bronze-hued. It is early October: ninety-one years ago Picasso was born during this month in Malaga and the thought of him occupies, now and for ever, a special corner in my memory. Picasso has long ago ceased to be, for me, the stranger whom I loved and rejected. Nowadays it is at nature's own gentle pace, each moment being unique, that he lives on.

The silken feel of the birch trees, as I run my fingers over them, contrasts with the rough texture of the bull's hide which covered Picasso's bed, where I used to sit patiently waiting while he made tea for me in that winter of 1944–5. He would get water from the tap of the bath-tub, then bring in the tea-pot and cups and place them on the floor beside the stove. And while I was drinking my tea he would go and fetch the drawings and engravings which he had done during the week. He spread them out on the red tiles and I would crouch down to look at them. I used to tell him what I felt, confining myself mostly to such brief remarks as 'I like it' or 'I like it less' – I had learnt prudence! If it was the former, Picasso with a somewhat ironic smile would reply: 'Well, so much the better.' But the latter comment, to my surprise, made him sad. I was always rather afraid that Picasso might ask me my reasons for liking or disliking something, though luckily he never did.

On the other hand, my admiration, not to say envy, of the bull's hide grew more apparent each week – it must have had something to do with my early reading of fairy tales about log fires, animal hides, princesses and Prince Charmings. Anyhow, the upshot was that one day, in the most charming and inviting way, Picasso said to me: 'Well, if you like it so much, why don't you stay here?'

I thought he was making fun of me and was rather put out. For, apart from a few unthinking moments when I was able to forget who he was, I was puzzled by the interest which Picasso continued to show in me. Even discounting my adolescent self-assurance, I could not believe that I was that fascinating!

66

Six years later, however, I stayed. In the meantime, I planned to go to America, and was able to realize my project at the end of that first winter with the help of Picasso. Then Françoise Gilot, the girl friend of the painter André Marchand, came on the scene – introduced to Picasso either by Marchand himself or by Alain Cuny,[36] both of whom have claimed responsibility. Picasso set up house in Antibes, then in Vallauris, and his children (Claude and Paloma) were born. During that time I was wandering in the Scandinavian countries, after tasting the joys of life around St Germain-des-Prés, in the days of La Rose Rouge,[37] the Frères Jacques and Juliette Gréco. Whenever I was in Paris, I would go to see Sabartès, who had been left in charge of a more or less deserted studio. It was during this period that he asked me to work with him on various translations.

One day in 1951, I telephoned the studio and Sabartès answered. At the other end of the line I heard noises instead of the relative stillness to which I was accustomed. Someone asked Sabartès a question, and I heard him reply: 'It's Geneviève.' At once, another voice which I had never forgotten came on the line: it was Picasso. He asked me to come around right away. My heart beat faster and I complied as quickly as I could.

Nothing, it seemed, had changed since my initial visit, except that, during that first winter in which our friendship became increasingly intimate, Picasso had cut off his magnificent white forelock. He now appeared bald. I remembered that this had saddened me, and that I had been very angry with Aragon, whom I accused privately of hypocrisy when he rejoiced over it and told Picasso: 'That suits you much better and makes you look younger.' So I found Picasso virtually the same as before, just as suntanned – it was springtime – and with the same effulgent glance, though I thought I detected in him an underlying sadness, even hardness, which I did not recollect. Perhaps I had just failed to notice it; after all, six years previously I had still been very young and without much experience of facial expressions. Picasso took me in his arms and for the first time gave me a big kiss. Those of his friends who were standing around looked on in amazement. No words can tell how happy I was to see him again.

All at once we were like two children meeting again after the school holidays, and as he led me towards the studio he asked: 'Do you remember when you were little and I used to make tea for you?' To which I replied: 'And you fed me on American chocolate. Once too, do you remember, some friends ate it, and you were so apologetic that you searched around for something to replace it with and then appeared with tea and a toothbrush which some GIs had given you that morning?'

And on he went: 'Have you still got the little bear?' I was overjoyed to hear the long list of charming little details which he had never forgotten. Of course I still had that little woolly bear covered in sequins – it looked like sugar – and holding a flag in its paw. I was beside myself with delight. Picasso in presenting it had used words that I was to hear so often: 'You like it? It's yours.' I went home that day in a blissful mood with my little toy: it was Picasso's first present to me. But my various changes of residence after that had taken toll of my little bear.

I looked around me: there were the same sculptures I had seen six years earlier. The May sunshine had chased the grey from the Parisian sky. Picasso's welcome was as warm as ever and less reserved. Absence and the passage of time had worked on him as they had on myself. He quickly invited me to stay for lunch, which was the first of a succession of such meals at which the ritual was unchanging. Picasso received, first of all, those visitors whom he did not wish to invite to his table. The others were asked to stay behind. At about two o'clock, the attractive Inès, who Picasso had discovered picking jasmine in the fields near Mougins with her two sisters, and had brought back to Paris with him, set about freeing a large part of the enormous table in order to lay the meal. Then we sat down – generally six people, sometimes less, rarely more. Inès was an excellent cook, and I remember with special pleasure one of her Cuban dishes with fried bananas, fried eggs and sausages, piled up on a pyramid of rice, which made a still life as pretty as it was tasty.

Picasso's guests were a mixed lot. One morning, he pulled me aside as soon as I arrived and whispered: 'Do you like beer?' I said no, without understanding what was going on. Then he pointed

2 Ink drawing of Geneviève Laporte by Picasso, dated 29 July 1951

2 Manuscript of a poem written by Picasso at Vallauris in 1951

3 Geneviève Laporte and Love's Messenger. Ink drawing by Picasso dated
29 July 1951

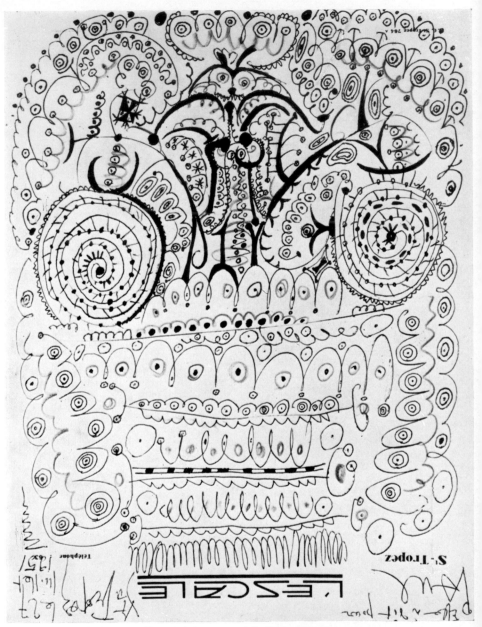

4 Owl (1951). Drawing in coloured chalks by Picasso, *see* p. 33

5 Picasso and Braque at
Varengeville (1952)

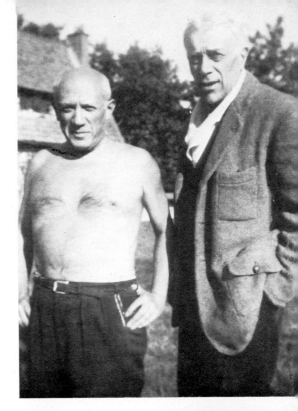

6 Picasso at Vallauris with his
children Paul, Claude and Paloma
(1953)

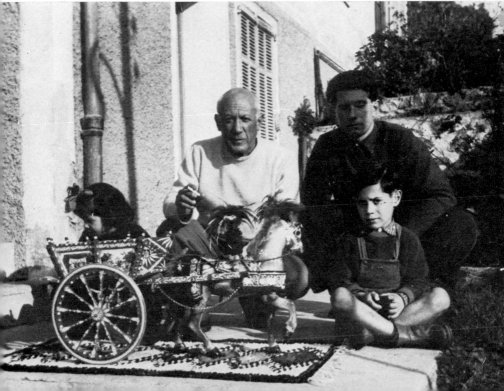

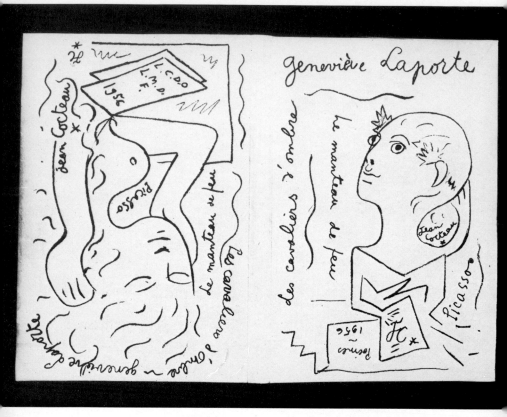

7 Cocteau's cover design for the 'two-headed' volume of poems by
Geneviève Laporte (original lithograph, 1956), *see* p. 110

8 Cocteau in Mourlot's lithography workshop tearing the edges of a proof of *Harlequin*, an illustration for *Sous le Manteau de Feu* (1954), *see* p. 107

9 Geneviève Laporte with Jean Cocteau (1955)

10 Geneviève Laporte with her Great Dane Elfi (1955) *see* p. 111
11 On her horse Quel Roi (1973)

to an English couple in the room, very pink and white, and added: 'She's Guinness's stout. They're very rich. You wouldn't know it, would you?' But what 'Guinness is good for you' said at table has left no impression on me at all.

On the other hand, I have a clearer memory of visits by Kahnweiler, the art dealer. Eluard somehow felt sorry for this thin, ascetic-looking man – that's how I remember him – who 'had spent his life running after Picasso to buy whatever Picasso felt like selling him'. Ever since Picasso had put the misery of his early years behind him, he suffered when he had to part with one of his own works. And on each occasion he grumbled. He always told me, in fact, that *Guernica* was 'on loan' to the Museum of Modern Art in New York.

Picasso saw his paintings as some sort of intimate journal or photograph album. Each period was bound up with a specific part of his life, which he hated to give up. Whenever something left the studio, he felt as though he were ripping off a part of himself and throwing his private memories into the street. I was, therefore, very surprised to discover one day that Picasso also kept some kind of journal. The one he showed to me contained a lock of Dora Maar's hair, which prompted an explanation: 'I wasn't in love with Dora Maar. I liked her as though she were a man, and used to say "You don't attract me, I don't love you." You can't imagine the tears and hysterical scenes that followed!' He stopped for a minute, and it was evident that he was trying to resolve a doubt. Timidly I ventured: 'It's not surprising then that she went mad.' He stared at me fixedly and recovered himself: 'It was horrible. They gave her treatment. Paul Eluard was of great assistance to me . . . And do you know, when she recovered, she was no longer able to do any good painting.' I knew it, because Picasso had often told me so.

Carried away by his own train of thought, and delighting in ideas which seemed paradoxical, Picasso went on: 'I'm a woman. Every artist is a woman and should have a taste for other women. Artists who are pederasts can't be true artists because they like men, and since they themselves are women they are reverting to normality.' He was amused by this idea, smiled and looked at me

69

out of the corner of his eye. I was older and no longer blushed. But no matter – and it is time to get back to Kahnweiler. In the early 1950s, Picasso was having difficulties with the housing authorities, who were determined to evict him from his apartment on the Rue la Boétie, in which he had not lived since he separated from his wife Olga. Picasso, who liked to preserve a period of his life in the setting where it had been lived, had left the apartment as it was and gone off to live elsewhere. 'Rue la Boétie' had a period significance for him as did the '*bateau-lavoir*' or 'Céret' and later on 'Vallauris' or the 'Grands Augustins'. I never heard Picasso talk of the blue, pink, cubist or any other period of style. He would situate things concretely in time by referring to the place where he was then living. So the apartment of the Rue la Boétie was full of all sorts of treasures, cubist and others.

One morning, then, I found Picasso very preoccupied because, although he had gone round to the apartment with a Minister – Claudius Petit, I think – to have the seals on the door removed, the threat of expulsion was more real. An ordinance had been issued calling on Picasso to hand over the apartment to Jacques Chabannes.[38] And his friends in high places were powerless to get this ordinance revoked. So with death in his soul Picasso began to move everything out. I think he sent the furniture to a warehouse. But the hundreds of paintings, drawings, *papiers collés* and prints, as well as a small theatrical model, which he had been given by Marcel Herrand,[39] were transported in several loads by Marcel to the Rue des Grands Augustins and piled up anew. Picasso kept looking out of the window impatiently to see the large white car arrive, and before Marcel could climb the three flights of stairs with the various packages in his arms, Picasso was waiting at the door to receive him. He seemed to take an almost childlike pleasure in rediscovering, with many an exclamation, his forgotten treasures.

Kahnweiler thought this was a good moment to appear and a day or two later was closeted with Picasso. I, of course, was not present at this meeting, but when the dealer left I noticed that he had a look of contentment on his face, whereas Picasso was glum. That day we had lunch together alone, because Picasso had not asked any visitors to stay behind. Hardly had we finished our meal

before he led me into the room where he had received Kahnweiler and showed me a pile of drawings and prints. From the moment that Kahnweiler had left, Picasso had become more and more gloomy. Pointing to the pile, he said: 'I sold him all that.' And when I inquired why Kahnweiler had not taken them away with him, he answered: 'Because I have to sign them.' Picasso began to frown, then to look at each drawing separately, holding it at arm's length because he was long-sighted. The lot consisted of several works from the Rue la Boétie, and others of a more recent date, including a number of very attractive portraits of Françoise Gilot as half-woman half-flower.

Picasso began to mutter sullenly: 'I really don't see why I should sell all this to that scoundrel Kahnweiler.' The insult was not really meant, for Picasso had a genuine affection for Kahnweiler and was grateful for what he had done to help him. But at that moment he had become an enemy. Picasso began to make two piles, one of which grew bigger every minute as he added, nearly all the portraits of Françoise and much else besides, before he finally said: 'That's for Françoise, it's the portrait of Françoise.' At the end, the second pile was quite small. Picasso put it aside, got up smiling and was obviously pleased with himself: 'There we are. All that (it was less than a quarter of the whole!) is for Kahnweiler.'

Picasso had recovered his good humour and went off to conceal the large pile in one of those private hiding-places whose exact contents he knew by heart, much to the astonishment of his visitors and friends. Even Cocteau, who had a remarkable memory, was impressed by this extraordinary gift of Picasso's. 'Have you noticed', he once said to me, 'how in the middle of a conversation Picasso will suddenly say "Wait a minute!" and rush out of the room? Then a few seconds later he will reappear brandishing some object or piece of paper which has been mentioned and which he tucked away perhaps twenty or thirty years ago. He's incredible.'

I was not present on the following day to witness Kahnweiler's mortification. But a few days later Picasso asked me to 'help him with some work'. I stared at him in amazement, because I could

not imagine what I was expected to do. Then he showed me a pile of about one hundred drawings lying on a table. 'There. I have to sign them. Kahnweiler has brought them back.' He started to laugh over my surprise at the need for a hundred signatures. 'Though you may not think so, it's not a bore at all. Do you know why? My signature is like a drawing: I invent it each time afresh. It's not the same twice running – I couldn't do it. Look, one day a man arrived with a painting of mine which he had bought some place and which had been damaged. He wanted me to do something about it. I just painted over the old one!' He laughed heartily. 'I wish you could have seen the man's face. It wasn't his picture any more! But I've never been able to copy, neither myself nor anyone else.' I thought of his composition after Cranach, but he led me to the pile of drawings saying: 'We're going to work in tandem. You will hand me the drawings one by one and I'll sign. You'll see how quickly we get through the pile.' I started out in a sceptical frame of mind, but Picasso was so practised in the technique that everything was signed in no time at all. Then he looked smugly at the pile and inquired: 'Five hundred multiplied by 100 – how much is that?' I did the sum in my head, and with obvious relish he answered: 'We have just earned fifty thousand francs, because I make Kahnweiler pay five hundred francs for each signature. Now we'll go out and you can have an ice cream.'

We went into the Rue Dauphine and I was given an ice cream. Then we started to walk and ran into Monsieur Palewski exercising his dog.[40] He seemed startled to see Picasso walking, which was of course unusual. They exchanged a few words, and then Picasso had an idea: 'We'll go up to Lacourière's. Let's get a taxi.' We set out for Montmartre, climbed the steps of the Butte, and ended up in a dark printing establishment. Madame Lacourière received us in her little office, and Picasso seemed light-hearted and wholly at his ease. But as soon as he got near the printing presses, his look changed while he warmly shook the hand of the workman who was handling his plate. A proof of the *Venus* after Cranach was involved, and I was to see it standing on an easel in the Grands Augustins studio every time I went there

during the next ten years.[41] I have never seen the original painting which inspired Picasso's engraving, but the female figure, who carries herself like a page, has my silhouette and my long hair. Picasso did a lot of work on this plate, complaining all the while that, as he was now accustomed to the face and forms of Françoise, his hand automatically drew me with a longer nose and more rounded breasts. In fact I resembled at that moment the figure evoked by Paul Eluard in the *dédicace* he wrote in my copy of *Pouvoir tout dire. 'Comme une feuille consue de fil blond.'**

Picasso asked for a proof. He had put on his spectacles and we were joined by Madame Lacourière. The silence of the workshop was only broken by the noise of the press and of the paper when it was handed to Picasso for examination. Picasso studied it intensely, while the workman waited. 'It's too black.' he said at last, 'Use less ink.' The workman carefully re-inked the plate, while Picasso looked on, then passed it under the press. The moments of waiting for the new proof were tense. Once again, the noise of the paper. This proof was better, but still not satisfactory and several more had to be pulled before Picasso was content.

The potter who worked with Picasso at Vallauris told me that he would evoke 'with his hands' the forms he wanted. It was quite extraordinary to watch how men, or even the most recalcitrant materials, became malleable in his hands.

Picasso was surprised by the simplest things, by the softness of the skin on his own hands, for example, although he used them for all sorts of rough work: 'I've handled everything with them, wood, plaster, stone . . .'

'Yes' I added, 'and women.'

He was flattered and pleased by this reference to his conquests, which produced a further comment. 'You know, women have always created far more complications in my life than painting. Somebody once said to me, "You have the soul of a sultan, so you should have a harem." It's true, I would have enjoyed being an Arab or an Oriental. I'm captivated by anything to do with the East. The West and its civilization are little more than crumbs out of the enormous loaf represented by the East.'

* 'Like a leaf stitched with blond thread.'

73

Eluard was always sceptical about declarations of this sort by Picasso. 'He may have the soul of a sultan, but you must have noticed that he still wears a wedding ring, that he is not divorced from Olga, that the son he had by her is the only one to bear his name, and the only one he regards as legitimate.'

Notwithstanding those observations, Picasso was always very generous towards his other children, Maïa, Claude and Paloma, and their respective mothers, seeing to it that they lacked for nothing in life. 'A long while ago, I was accosted by a whore, with whom I spent most of the night walking and talking. She said finally, "At heart you are a man who knows his duty."' Picasso was serious though slightly embarrassed, as he told me the story and quickly added without looking at me: 'She was the most intelligent woman I have met.' I was, fortunately, not touchy on this score.

Picasso was more given than one would imagine to questioning the ultimate value of his art, as well as his own moral attitude. His mind constantly reverted to these problems along diverse paths of thought, the two aspects of his self-doubt often appearing in conjunction: 'I am full of contradictions. I love what belongs to me, yet at the same time I have a stronge urge to destroy. It's the same with love. Any desire I have for procreation is an expression of my other desire, namely to free myself from the woman in question. I know that the birth of a child will be the end of my love for her. I shall have no more sentimental attachment. But the child will bind me with moral obligations.'

Picasso looked at me appealing for support, and suddenly I saw a tragic and ageless mask impose itself on his face, which the moment before had been serious but alive: 'Do you realize that I have a sense of duty?'

The shadow of my horse is fragmented as it passes across the tall reeds and spiky shoots of the broom. Autumn is rushing upon us faster than he can gallop. The sun's rays which, throughout August and September, shone day after day on an unchanging

landscape, now filter between the branches adding sparkle to every detail. From dawn to midday they give colour to everything – ferns, oaks, birches and undergrowth sway in the breeze and take on a russet hue from the first layer of fallen leaves.

Picasso was familiar with this forest of Fontainebleau. He first went there with Olga when Paul, their son, was a baby.[42] But they had to leave because Paul's face became swollen with mosquito bites. Nevertheless, Picasso's eyes were already saturated with shades of green. 'When I got back to Paris' he explained to me, 'there was nothing but green in my paintings. I felt as though the foliage had given me indigestion and I was vomiting green.' I once saw one of these paintings, but woodland scenes are rare in Picasso's *œuvre*. I have heard him say that he liked 'poor desolate landscapes with bare rocks', and he could be annoyed when friends would not believe that he liked the country. 'When I say that I wish my home were in the country, people laugh and think I am joking. "Nonsense" they say, "you need Paris!"'

In my opinion, Picasso did not really care where he was. He took his own ambience with him everywhere, and all that mattered was being able to work. He also cared about having friends around him. But his true friends were ready to go and see him wherever he was – and even more so those he could do without! Picasso was not taken in by people, although he might pretend to believe in their declarations of friendship and himself show signs of returning it. Many was the occasion when he surprised me by his comments on some visitor who had just left, because while he was present Picasso's behaviour had suggested a different attitude.

Picasso had a taste for paradox, even a desire to provoke for the sake of seeing what would happen. I remember, for example, that he had hardly finished telling me how much he loved the country before he was saying with a wink: 'One day I went to the country, and what do you think I painted? A house.'

I think Picasso was ready to accept anything – town or country – provided he found there some form of spiritual nourishment. As we walked in the green meadows around Barbizon, which in June are enlivened by cornflowers, poppies, gorse and clover in full bloom, Picasso described to me how the impressionists

75

composed their paintings (like nature itself) by juxtaposition of colours. 'They knew a lot...' he commented, then fell silent while we walked on one behind the other. Next, pursuing a private train of thought for which I was unprepared, he added on a serious note: 'Colour spoils everything. You see, one advantage of lithography is that there is always a record of each state, because the proof remains even after the drawing on the stone has been completely transformed.' It wasn't always easy for me to follow the logic of his thinking when he took such a leap.

But fortunately Picasso never lost touch with a sense of reality and the practical conclusion followed at once. Looking around him, he took in everything: 'I am going to give you a bit of advice, which, coming from myself, you may find surprising. You want to be a painter? Well, look at what's around you. You don't look nearly enough.' He could read my thoughts in my expression and the questions I dared not ask, for I was thinking of those dislocated heads which his detractors dismiss as having a nose put on crooked and two eyes on the same side of the face.

Picasso bent down, picked up a pebble, laid bare a patch of dark brown earth and drew there two eyes, commenting the while: 'The pupil should be drawn like this, ◀ and not like that ◀.'

He got up, wiped his hands on his trousers, frowned and with a sigh muttered to himself: 'And then they accuse me of deforming.'

Another day, at St Tropez, Picasso took a ball-point pen and drew on each of my knees a face in blue ink. They were deceptively life-like: at every step I took the face would change shape, make grimaces, or appear to laugh. I felt obliged to bend double as I walked to follow the transformations of these drawings. I tried to preserve them by washing myself only up to their edges and not bathing in the sea, but outside forces proved too strong. And before long these two characters, who had assumed a strange, even frightening reality on my skin, were obliterated. Picasso had once made similar drawings on the knees of Jeannette Vermersch, the wife of Maurice Thorez, who was delighted.[43] Like myself, Jeannette hated to have to wash them off. So Communists do sometimes have the same reactions as bourgeois!

76

Cleanliness was only one of many subjects about which Picasso would state an opinion and do exactly the opposite. Cutlery, he would announce with malicious delight, was only invented for the use 'of common people who could not eat decently with their fingers.' Yet I never saw him use his fingers. Indeed he was fastidious in the extreme. Picasso would get out of the bath-tub, pick up a bottle of *eau-de-Cologne*, point mockingly to the label and say with a laugh 'Gilot, the father of Françoise', then rub it over his skin energetically. Afterwards, he would look with horror at his towel and call me in as a witness: 'Look, I have just washed myself, but when I rub my skin with *eau-de-Cologne*, black still comes off on the towel.' He would do it again until his bronzed skin began to redden. And more black would come off on the towel. Frustrated, Picasso would inveigh against 'the cussedness of things'.

Then his mind would leap from a casual remark about *eau-de-Cologne* to a much higher sphere. 'Things can also take their revenge. As a result of painting faces from the inside outwards, I am inevitably more than just a portrait artist. What's more, I can't do the portrait of just anybody. It's a long time since I had a "model" in the generally accepted sense.'

All of a sudden he recollected something funny and his eyes lit up. 'One day' – Picasso's characteristic opening phrase – 'Helena Rubinstein asked me to do her portrait.⁴⁴ I answered, very rudely, that I only made portraits of women I had slept with.' I smiled, because jealousy, which Picasso always said was 'contagious', never came between us. Picasso was perhaps a bit disappointed and went on with emphasis: 'But you don't know the best part of the story. She wasn't against it, though I certainly was. She was horrible, so fat . . .'

Picasso's references to his society acquaintances were as episodic as they were unexpected. From Helena Rubinstein he passed to Coco Chanel. 'One day, (yet again!) I was invited to a ball given by Etienne de Beaumont, in his house on the Boulevard des Invalides. And who do I see sitting on a bench near the house? Coco Chanel. She was furious because she had not been invited. So we both spent part of the night sitting together on the bench

and watching the guests arrive. Somebody must have told the host. But I no longer had any wish to go in and thought it much more fun to remain on the bench.'

This led Picasso to talk about Pierre Reverdy,[45] who he respected highly as a poet, though I had the feeling that the nature of their friendship was not so free as that between Picasso and Max Jacob. 'Reverdy turned mystic and converted his wife to Catholicism. They went off together to the Pyrenees and led a monastic life until the day Reverdy met Chanel . . .'

'Why are you surprised that I go out into society? Eluard, you know, often did. Once we were both invited to a reception given by a Russian prince. Someone had brought a little monkey which had a diamond-studded waist-band. Eluard was outraged and choking with anger, but I wasn't. The little monkey wore his diamonds far more elegantly than the fat old ladies.'

Whenever Picasso revealed his love of animals, even with such partiality, I listened intently. But on this occasion I could not help coming back to the one subject on which our views were divided: bull fighting. He was somewhat embarrassed and tried to produce an argument in justification: 'What I particularly enjoy about a *corrida* is going to watch the matadors being dressed and getting ready. Each has his own little portable altar with holy images, medals and so on – it's very pretty, you know. You'd like it too.'

I remained unconvinced and sullen. 'Wait a minute!' said Picasso, and he disappeared. Of course, by that time the battle was half won, but I waited nevertheless to see what he would dig up out of his hiding place. A few seconds later, he was back, wearing on his head a wickerwork bull's head, snapping his fingers and miming a dance. He had won, and I laughed. Then he took off the mask and showed it to me, saying: 'It was a present from Dominguin.[46] Now I'm giving it to you.'

High up on one of the white walls of my house, the bull's head sleeps by day, but it lights up at night to watch over the first two prints that Picasso gave me, in 1945, in each of which a lamp figures. My mother told me never to accept presents, but Pablo overcame my resistance by presenting these in the guise of an exchange: 'You have brought sunshine to me, so it is only fair that

I, in return, should give you light.' And I have kept that light ablaze ever since.

The sky is overflowing with golden light. As it filters downwards, it catches on the leaves and draws them out. The last insects which venture to enjoy the sun's unaccustomed warmth are forced back into the ground. My horse stumbles in the sea of dead leaves which cover the path. Under the hill, the chestnuts and beech-nuts fall and burst open. Autumn in all its splendour is on the move, marshalling its ranks of russet ferns and spinster-like heather. The rocks lead the way and are covered by twittering sparrows. Suddenly, from high above, a bird of prey screeches – a sparrow-hawk or a buzzard? Then, by a characteristic twist of memory, I feel myself plucked from this peaceful forest and locked in the grip of Picasso. For I remember how surprised – not to say frightened – he said he had been by a recurrent childhood dream, in which he was an eagle in flight.

It is easy enough with hindsight to find a symbolic explanation. But I cannot believe this symbolized a desire to dominate. Picasso had elected to follow one path, and one path only; there was no going back later. So he had to fly high ... or fall and break his neck.

Did Picasso believe in dreams? He never commented on this one. On the other hand, he assured me that he believed in magic, in the magic of words for example – one could therefore never talk of death in his presence, because he was afraid of it. He also believed in the magic of things and what he called their 'cussedness'. For example, he got very cross with one of the little terracotta roundels with heads in relief on them which he had given me. He threaded it himself on a string and tied it around my neck. But with an obstinacy which seemed to amount to ill will, this particular roundel insisted on turning back to front, so that the head was against my skin. Picasso, furious, challenged the object: 'What difference can that make to it?'

He turned it over, but a few minutes later it was once again back to front. Then he had a new idea: 'Wait a minute, I will force it to

stay as I put it. I'll stick two of them together.' And he did, so that whichever way the medallion turned it would be bound to show a head. But, alas, it now decided to stand up on edge. Picasso looked disappointed and said no more, and I gave up wearing the medallion.

For several days afterwards it lay around on a table, and Picasso would cast a sidelong glance at it as he passed. It seemed to hold some fascination for him, as did also a very large amethyst with a captive drop of water inside it which evoked for him a tear. Picasso turned the stone over and over, admiring nature's handi-work and fighting in himself a violent desire to break the stone and free the drop of water. He was irritated at heart by the presence of something within reach which he could not touch. This drop of water imprisoned within a hard but transparent shell, near at hand but inaccessible, started Picasso on a train of thought leading naturally, to Psyche . . . and Love.

The subject was close to Picasso's heart. 'I feel a constant urge to destroy what I have built up with much difficulty. But you have always succeeded in setting my heart at rest.' Mentioning Psyche in passing, Picasso took up the theme of sleep, which runs through the whole of his work. Sometimes he has shown a man asleep watched over by a pensive woman, at others he has reversed the roles. 'When a man watches over a sleeping woman, he tries to understand. When a woman watches over a sleeping man, she thinks about eating him in a delicious sauce.'

This was not a facetious sally. Nor indeed were those aphor-isms in which he commented on the detail of everyday life. One morning, Inès served us toasted *brioches* for breakfast. Picasso ate them and said they were good. But then he stopped eating, his face lost its mobility and in a serious tone of voice he remarked: 'One must not pay too much for happiness, because that depreciates its value – even if you have a lot of money.' Then, as I watched him mechanically turning the spoon in the pot of jam, I realized what inspired this thought, for he went on: 'It's the same with jam. Like it as much as you will, but if you indulge too much, it gives you nausea.'

Did I detect some threat underlying these words? Was Picasso

afraid of his happiness, afraid of succumbing to a more profound emotion than he was willing to cope with? I felt tears coming to my eyes. He smiled sweetly, caressed my neck, and reassured me with a few infinitely tender words: 'All my adventures in love have been spoiled by something that grated. For the first time, I am happy.'

This sufficed to calm my fears, but my exhilaration only returned later when I heard Picasso tell Eluard: 'You know, don't you, that all my affairs of the heart have been spoiled by friction and suffering: two bodies enveloped in barbed wire, rubbing against each other and tearing their flesh. With her, it's been all sweetness and honey. She's a hive without bees.'

'Only in winter can I depict spring, and in prison I would sing of liberty.' This sentence by Rousseau comes to mind as I start to write about a certain evening in July 1951. Picasso had returned from Vallauris two days previously, after being a witness at the wedding of Paul Eluard. This event had reminded him that Apollinaire had written a poem on the occasion of his own marriage to Olga. Not that Picasso was nostalgic. He was living fully in the present of a marvellous Parisian summer. Picasso merrily informed me that I would shortly get a letter from Eluard, whom I had not seen for a few years. 'I've asked him to find us a place to rent for the summer in St Tropez. I'm sure you will like it. Paul and Dominique have an apartment there looking over the harbour.' A few days later, I received a letter from Paul signed with his curious signature resembling two crossed swords. Picasso decided that we would leave for St Tropez next day. I was delighted, more particularly because during the previous few weeks I had felt the upsurge of a lyrical strain. I wrote one poem after another. Picasso, who read them carefully, thought that I had found an appropriate form of self-expression. 'When your poems are finally polished I'll do some drawings to illustrate them.' This was for me the most perfect gift to offer.

Without saying a word to Sabartès – which upset me, because I

did not think he merited this mark of distrust – Picasso and I left. With us in the car was a lithographic stone, which Marcel had to unload at every stopping-place because Picasso intended to work on the way down. His intention remained, but in fact the stone was as immaculate on arrival as when it went into the boot at the moment of our departure. We travelled in a leisurely way, by stages. On the first day we got no further than Fontainebleau. On the following afternoon we were in Moret. 'At this pace' sighed Marcel, who longed to take advantage of the powerful engine of the car, 'you might as well have gone by coach.' These were my feelings too, though I was enjoying it. For poems alternated with drawings, which in turn prompted new poems. I had no illusions about the worth of my talent, so on each occasion I waited anxiously for the verdict of Picasso. Ironically, I remarked: 'You'll soon be saying to me, as Musset did of George Sand: "And the blackbird went on laying and laying."' But he encouraged me to go on, without once offering any advice. The art dealer Rosenberg, he told me, had once said: 'When a painter asks me, "What do you think is wrong with my picture?" I always reply, "I'm not there to criticize because in that case I would be painting the picture and not you."' Picasso's only advice was: 'Go on working!'

Eventually we arrived at Aix-en-Provence, where a roadside hotel-keeper, seeing how Picasso was dressed, turned us away. So we drove on until, late in the evening, we reached the Auberge Sarrazine, at La Garde-Freinet. Picasso telephoned to Paul Eluard right away and invited him to lunch on the next day.

At the end of the morning, Picasso started to walk down the road lined with cork-oaks in the direction of St Tropez. Time ran on, and there was still no sign of our guests. Picasso began to get worried, because he was looking forward to sharing a few hours of happiness with his old friend. We sat down on the side of the road, occasionally a car passed but none of them belonged to Dominique. Paul, like Picasso, had never had the patience to take driving lessons. The very idea made him either laugh or exclaim in protest, depending on his mood at the moment.

Eventually we heard the whirr of a wheezy engine. Picasso got up. 'That's them!' and we saw an old, dark blue Renault chugging

82

up the hill. Picasso waved. The car stopped and Paul got out, followed by Dominique who I now met for the first time. They both greeted us coldly. Paul, whom I was happy to see again, remained distant, while Dominique, apart from a formal 'How do you do?' on arriving and 'Goodbye' on leaving a few hours later, never addressed a word to me. I could not understand it. Picasso appeared put out, even deeply hurt. We got into the back of the car and were driven the few hundred yards back to the hotel, but at lunch the conversation between Picasso and Eluard was banal and their embarrassment mutual.

By the end of the meal, I could stand it no longer and disappeared, followed by Dominique who ostensibly went to fiddle with her car, which had given them trouble that morning and made them late for lunch. Paul and Pablo were therefore left alone together. When I came back, Picasso was not so much glum as smouldering with anger, while Paul was starchy in a way I had never known before. They were sitting outside under the vine trellis and Picasso was saying: 'I was in a terrible state and she saved my life, as they say of doctors. She made me laugh, don't you understand?' Picasso saw me appear and repeated for my benefit: 'You have made me laugh.' At the same time, I noticed that his eyes had that anguished look I had seen in photographs. I had already remarked to him that while he smiled with his mouth there was always a hard, despairing look in his eyes, except nowadays when his eyes too had begun to smile. Several times after that as he looked through the snapshots I had taken of him, Picasso's face would light up as he nodded his head and said: 'You're right, both my eyes and mouth are smiling. When I say you make me laugh, you see, I might as well say you give me new life.'

Eluard was embarrassed and said nothing. I began to wonder if he had forgotten those early days when, on instructions from Picasso, he took me to a café for a glass of white wine, but found to his surprise that I ordered nothing stronger than grape juice. Then we had gone looking for old books in the Rue de Tournon. That is where he gave me one day in 1945 a copy of the first edition of *Argonne*, published by the Editions de Minuit, and already very rare. On the first of these walks, Paul nonchalantly let

fall: 'If I were now eighteen, I would be courting you.' This had astonished me no less than Picasso's suggestion that I should stay 'because of the bull's hide'. So I had as much reason to be hurt by Eluard's present attitude as had Picasso, but the explanation was not forthcoming for several weeks, and then I was to hear it from Dominique after we had got to know each other better.

'Just the week before we came to lunch, Picasso had attended our wedding with Françoise.[47] Françoise indeed was my witness. And as I like Françoise very much, I was shocked to see Picasso with you only a few days later. I thought it was a whim on his part, an unjustified slap in the face for Françoise.' However, Dominique soon realized her mistake, and after we had spent a few days in a hotel with the incredible name of Latitude 33, which was virtually empty apart from ourselves, she led us to the little house in the Rue des Bouchonniers which we rented.

After lunch at La Garde-Freinet, Paul and Dominique left quickly and then Picasso's scorn poured forth: 'A young poet once went to visit Frédéric Mistral[48] to show him his poems. Mistral advised him to abandon poetry and take up a profession. As he left, the young poet turned to Mistral: "I came to see a poet, but all I find is his business adviser offering me fatherly advice." Well, that's the situation between myself and Paul – all I saw today was the businessman.'

Pablo and I spent a rather sad evening together. But next morning the telephone rang and Dominique asked us to lunch in St Tropez. Picasso felt like refusing, but eventually accepted. A short wander through the streets of La Garde-Freinet had restored our good humour. We left the Auberge Sarrazine, took the winding road downhill and I found myself for the first time in St Tropez. I was captivated. The little harbour, seen from the window of Eluard's apartment, seemed like a haven full of toy boats with sails. It was the end of the morning and people were beginning to gather on the terraces of the cafés. Women were walking past carrying little baskets full of heads of celery, purple aubergines and golden peaches. The heat took the colour out of the sky, while my nostrils were assailed by unfamiliar odours.

I was much astonished to find that the Eluards gave us not

merely a cordial but even – especially on Paul's part – a friendly welcome. After lunch, Dominique discreetly disappeared, and I did the same. When I returned, Picasso was positively joyous.

'The poet has come back to us' he said, and went on to tell Eluard the story about Mistral. Paul smiled and turned to me: 'We've been talking a lot about you. There is no solution to the problem of Françoise which is upsetting Picasso, because there is no real problem. *Carpe diem*.'[49] Then he faced Picasso: 'But even if you had complete freedom of choice, no solution would make you completely happy.'

Picasso's face fell and a look of distress was in his eyes as he asked: 'Who has to be killed?' Eluard, talking slowly as usual and with the patience of someone trying to explain a single point to a schoolboy, answered as he looked out to sea through the window: 'Another false problem. No matter who gets killed, you will make the other two unhappy.' Picasso's face registered pain, because he felt that the friend he had found anew did not understand him. So he laboured the point: 'I was on the point of killing myself, but she made me laugh.' And with anguish in his voice he reiterated: 'Laugh – do you understand? – she made me laugh.' To which Paul, on a serious note, yet with all the affection he could muster, answered: 'Even if she had made you cry, she would have saved you.' Dominique came into the room and found all three of us silent in the grip of a common emotion.

That ended it. The subject was never mentioned again, and we spent a gloriously happy day on the more or less deserted beaches; in the *bistros* round the harbour; walking down paths lined with aloes and cactuses, or through pinewoods smelling of resin and enlivened with hordes of chirping cicadas; going to the Quai de Suffren, where according to Paul one could witness the most beautiful sunsets of the whole coast; and listening to the mechanical piano at the bar Palmyre.

There was, however, one bone of contention. Paul Eluard was about to republish *Au Rendezvous Allemand*,[50] a volume of his poems which had appeared during the Occupation. He wanted Picasso to do some illustrations for it. Picasso agreed half-heartedly, but did nothing. Several times Paul returned to the

charge and Picasso replied in the affirmative, while avoiding any precise commitment. I tried to find out why and he answered crossly: 'I can't do it. To hell with the *Rendezvous Allemand.*' I was shocked by this reply and reminded him of his friendship for Paul. Then Pablo began to explain: 'You see, the *Rendezvous* was composed at a time of great unhappiness. But for the first time in my life I am totally contented. How do you expect me to draw misfortune?'

'Then you should tell Paul.' Picasso looked away: 'You know that's not possible.' Picasso was aware of my disapprobation and tried to clear the the air by making me laugh. 'Look, I will give you a parody of the poem *Liberté*' and with a malicious smile he began:

> *Sur tes jupons de falbalas*
> *Sur le polochon et sur le reblochon*
> *Sur le paillasson et sur le saucisson,*
> *J'écris ton nom . . .*

Seeing that I was not much amused, Picasso tried to force matters:

> *J'écris ton nom . . .*

There was a pause, and then with a great guffaw:

> *Avec ma . . .!*

Even after this outburst, however, he kept promising Paul and Dominique: 'Yes, tomorrow, tomorrow.' So in the end Dominique gave Picasso an album to draw in with the gentle hint: 'For the *Rendezvous Allemand.*' Picasso took it and in due course, using either a ball-point or a reed pen (also a present from Dominique) dipped in Indian ink, covered its pages with a series of drawings on the theme of love. Some of these included Picasso himself in the guise of Cupid, Cupid as painter, or Cupid holding up a mirror to a lady. But what touched me most was that this series seemed to reflect one of those rare moments when Picasso's work was wholly without bitterness. There was nothing in these drawings except purity, tenderness and love.

Throughout the summer we lived intensely the hours of each day. We had time for everything, for walking in the hills, for

bathing, for endless discussions, and still there was time to spend with friends, particularly Paul and Dominique. I loved to listen to the others reminiscing or discussing painting and poetry. Paul was the more talkative. Picasso only opened up when he and I were alone, and many of our conversations lasted until dawn. To Paul it made no difference where we were, at Palmyre with the mechanical piano which he enjoyed and Picasso loathed, or on the Pampelonne beach which he preferred. He was constantly turning the conversation back to a subject which preoccupied him: 'I have never written a poem which I really liked. Other people have found beauty in my writings. Not me. It's the same with you. You've never painted the picture you have dreamed of. That's lucky, because if you had you would have stopped working.'

Picasso listened in silence and nodded approval. Then Paul went on: 'You've always wanted to escape: from painting, from your affairs of the heart, from everything!' Later on, back in his own apartment, and pointing to the paintings hanging on the wall which were forcibly separated from each other by their frames, he continued: 'I would like to write only one poem. I dream of an unbroken stream of poetry. You too wish that your work could be all in one piece.' He walked out onto the balcony, looked at the sea where the sunlight was bouncing from the crest of one wave to the next, and on to the far away pale blue horizon. Then he remarked: 'Landscape doesn't stop, it is unending. In the same way life and death are inseparable.'

This was to be the theme of Eluard's poem *La Mort, l'amour, la vie* which he recorded the following summer. On the cover of the disc was a profile drawing of Eluard by Picasso, but by the time it was put on sale Paul was dead. So it was Dominique who gave me the disc 'on Paul's behalf', while Picasso added his signature and a drawing of a dove with a branch in its beak symbolizing hope. Paul died, in November 1952, in his apartment on the Rue de Gravelle, where during the preceding twelve months I had often gone to lunch. Talking with him as he lay in bed, very pale, a week before he died, I said something about those all-day suckers called *Pierrot Gourmand* which I had so much enjoyed in my youth. Suddenly he said he wanted a red one, raspberry or

strawberry, no matter which. Dominique and I went off in search but could not find one in the neighbourhood, so I promised him one for the following week. But on the appointed day, I went first to Picasso's apartment in the Rue Gay-Lussac, where I heard from Inès that Paul had died that morning. Picasso had already gone round to console Dominique, so abandoning my box of sweets to Inès I hurried there myself. When I reached the Rue de Gravelle, Picasso had left, but a few friends were with Dominique who was marvellously dignified and restraining her tears at this moment of great sadness. I laid my hurriedly bought bunch of violets on the bed and ran away as quickly as I could to conceal my own grief.

A few days later, as Pablo and I stood among the large crowd of mourners who had gathered at the Père Lachaise cemetery, I was haunted by these lines from Eluard's last poem, *La Mort, l'amour, la vie*:

J'ai cru pouvoir briser la profondeur, l'immensité par mon
chagrin tout nu
Je me suis étendu dans ma prison aux portes vierges comme un mort
raisonnable qui a su mourir . . .
Je voulais partager la mort avec la mort . . .
Tu es venue, le feu s'est alors ranimé
*Le froid d'en bas s'est étoilé . . .**

Shortly after that Picasso sent me the copy of *Les Lettres Françaises* devoted to Paul Eluard, in which these lines were quoted, with the commentary: 'Why write?' The disappearance of Eluard was for me a shattering blow, but two years later, when I sent Dominique my own volume of poems *Les Cavaliers d'ombre*[51] I had been able to write as a *dédicace* a commemorative poem which took its place in my later volume *Sous le manteau de feu*. Picasso and I, standing side by side in Père Lachaise while the crowd filed past the grave, were so overwhelmed by memories and

* I thought I could shatter the depth, the immensity by my bare grief
 I laid myself out in my prison with unsullied doors like a reasonable corpse
 which knew how to die . . .
 I hoped to share death with death . . .
 You came along, the fire was rekindled
 And the cold down below lit up with stars . . .
 (translated by Douglas Cooper)

emotion that we did not speak but only exchanged glances. And then I remembered something which Paul had said to me one night while we were waiting for Picasso: 'Neither pleasure nor pain exist in a pure state. Even happiness requires enormous sacrifices, especially on the part of an artist. In love, it is difficult enough when one is separated, but together it is still more difficult, even if one is happy.' I cast a glance at Dominique, all in black, her face tense with grief. She was lost in a sea of red carnations and roses. Then I was caught up in the press of the crowd and carried away to the gates of Père Lachaise, where I found myself alone under a leaden November sky.

I had to leave St Tropez and go back to Paris in August 1951. Picasso accompanied me to the station and bought for me to read on the train a book by Jean Cocteau on cinematography. The book was one of Jean's stylistic displays in which he refused to avail himself of verbal abbreviations like 'cinema' or '*stylo*'. Almost as soon as I was back in Paris, letters and poems began to pour in from Picasso. He himself returned in September and once again we spent happy times in the Grands Augustins studio or going off on a sudden outing. On one of these, we ended up at La Grenouillère[52] and were sad to find that, on this island where Renoir and Monet had painted, there was now a big restaurant with rooms to let. So we decided that in future we would keep to our own neighbourhood. Picasso began to work on some engravings, entrusting the printing of his copper plates to his nephew Javier Vilato, of whom he was fond. He also pulled out a lithograph to show me, a *David and Bathsheba* after a painting by Cranach.[53] The date on the first proofs appeared in reverse because for once, said Picasso, he had forgotten that it had to be written back to front on the zinc. The plate shows Bathsheba richly dressed, seated in a garden and stretching out her foot to be washed by a serving woman, while David peers down at her with lust in his eye, from a terrace above. This proof is in black and white only and Mourlot has written about it in his catalogue:

89

'At the request of Picasso the sixth state, on zinc, was transferred to a stone. A lithographic stone is much nicer to work on, and especially to erase from, than a zinc plate. The stone was taken to Picasso's studio in the Rue des Grands Augustins in November 1948 and set up on top of a large iron cauldron. But Picasso did not work on it. "I'm frightened and haven't the courage to touch it," he told me when I asked how he was getting on. Yet in due course he tackled it, drawing in lithographic crayon or pen, erasing, improving the quality of the blacks. Perhaps Picasso would still be at work had he not decided to go south in early June 1949, when he asked me to fetch the stone and pull a proof for him. For the moment, the stone is in my printing shop, but I expect it will go back to the artist's studio before the drawing is finally erased.'

The proof Picasso showed me was pulled on a sheet of paper which had a silken feel. 'It's Chinese paper,' Picasso told me. 'They don't make much of it any more. This is the only proof of this state.' He looked at me, while I, fascinated by the lithograph, remained silent. Then Picasso said with a smile: 'Tell me, as you used to do, what you think of it.' I remained speechless, tongue-tied by the beauty and force radiating from this black and white linear image. He held out the sheet to me, adding: 'Take care not to tear the paper. Look, this is how one should hold a sheet of paper, with the thumb in front and the other four fingers behind. If you do it that way, you can handle large, heavy sheets without tearing them. Paper is as fragile as a crystal unless you handle it properly.' As I had not mastered his method, I preferred to slide both my hands underneath the sheet and hold it out flat. When, with some regret, I handed it back to him, he put it on the table, took a red pencil and wrote: *Pour Geneviève Laporte* (*épreuve unique*). Then he added the date and remarked: 'It's for you. Take care of it, because your print is unique.' Then he disappeared into a cupboard and returned with a very simple white wooden frame. Picasso himself put the lithograph into this frame and Marcel brought it round to my apartment that evening. A few weeks later, Picasso gave me a second lithograph, *The Toad*, identically

framed.[54] This time he allowed me to choose between proofs in blue, sepia and black inks. I chose the last, and Picasso wrote on it with the same red pencil: *Si tard le soir, le soleil brille. Pour Geneviève.**

The sun has turned wintry and its crimson rays play across the reddish-brown trunks of the pines, the jade-green beech-trees and the delicate-looking birches. October's smells are still in the air, but an acrid odour which assails the nostrils announces the mist to come. Chestnuts lying on a bed of dead leaves burst from their husks. Squirrels and does gambol noisily hither and thither. The birds have stopped singing and all one now hears is a continuous chirping.

25 October 1972: it is Pablo's ninety-first birthday. My memory flashes back to 25 October 1951. Picasso left me at the end of September for a few days. He too had some 'private business' to get on with. Also, he wanted to see if there was anything he could do about Françoise, who was writing him one letter after another, several of them – which I saw – containing threats. Madame Ramié of the Madoura pottery tried to poke her nose into the dispute, also by letter. This made Picasso livid. 'That one owes her entire fortune to me! What's *she* doing interfering? She'd better concentrate on business.'

Pablo wrote me beautiful, affectionate letters from Vallauris regretting that we were separated in a poetic vein which could have been that of any lover in the world. Preparing for his seventieth birthday, the town and potters of Vallauris, the Communist Party and many friends had decided that it was the right moment for a celebration. Almost the whole number of *Les Lettres Françaises* was given up to Picasso. On the front page, was a large photograph of him and headlines announcing tributes written by Francis Carco, Jean Cocteau, Pierre MacOrlan and Fernand Mourlot. Paul Eluard's tribute was to 'the youngest artist in the world'.

On the day of this great celebration, Picasso went to a flower-shop, bought twelve red carnations, packed them himself into a

* So late at night, the sun is shining. For Geneviève.

cardboard box and posted them to me with a card which read: *Pour Geneviève, souvenir de tous les instants, Vallauris, le 25 Octobre 1951.** On the envelope he wrote in the same red pencil: *Pour Geneviève, de la part de Picasso.*

It was at this juncture that Picasso, acting as he had so often before, decided to buy a very large apartment in Paris in a building on the Rue Gay-Lussac, which was being sold off by floors. By now, the Rue des Grands Augustins was associated with our life there together, so Françoise Gilot and the children would live in the Rue Gay-Lussac.

Then came the death of Paul Eluard. A few days later, Pablo asked me if I owned a copy of his book *Le Visage de la paix.*[55] Paul had told me that it was his first 'back-to-front book', by which he meant that he had written the poems to accompany Picasso's drawings, and he had inscribed my copy as follows: *Le visage de la paix, Geneviève, puissiez-vous le conserver toujours.*†

Pablo looked at the dedication, thinking sadly of the friend we had lost. He fell silent as he reached for a pencil and began to draw across the title page a face which filled the whole surface. Tearfully he murmured: 'It's true, a genius should not have ideas. He should be calm.' He completed his drawing and looked at me. I was by then in tears. Very gently he said: 'Genius has no wrinkles.' And as he spoke his face became furrowed with bitterness.

Blue sky, green pines, varicoloured foliage, and the screech of a jackdaw as it flies off. I am seated amid the heather, looking at the white stripe which runs down the muzzle of my horse from ears to nostrils. Suddenly the midday sun bursts through a veil of cloud and I begin to whisper:

Midi le juste y compose de feux
La mer, la mer toujours recommencée . . .

My horse lifts its head and rubs his cheek against mine, scratching it with the grasses he has been eating.

* For Geneviève, remembering all the moments.
† The face of peace, Geneviève, may you keep it always.

My mind goes back to the little cemetery standing right above the sea at St Tropez, where Pablo had asked me to recite this famous poem by Valéry.[56] I did so unwillingly, for who can speak those beautiful lines without spoiling them:

Ce toit tranquille où marchent des colombes . . .

The seaside cemetery of St Tropez was one of the places to which we used to walk, often very early in the morning before the inhabitants of the town were stirring. It was a marvellous place for a discussion, though death was one subject we never touched on. Picasso studiously evaded it. But a curious thought once crossed my mind there, and with a laugh I said to Picasso: 'Just think, in fifty years' time I'll be able to tell my grandchildren that I knew you, and I'll tell them lots about you.' I had not at that moment any thought of becoming a mother let alone a grandmother. But to my surprise Picasso did not share the joke. A cloudy look came into his eyes, he sighed, and I was so abashed that I dared no longer speak or move. He spoke first, and over the sound of the waves I was aware of his profound emotion. 'I am grateful to you . . . it is marvellous to think that when I am gone, someone who loved me will still be there to say true things about me, and not just anything.'

I was staggered and nonplussed by those few words, yet it is because of them that I have been writing this book during the past few weeks. They justify any pain I have inflicted on myself while digging down into forgotten layers of memory.

Picasso made an effort to smile and, pointing to the sea as though he were trying to amuse a child, continued: 'How does it go? *Quelle paix semble se concevoir* . . .'

Then I took over:

Quand sur l'abîme un soleil se repose,
Ouvrages purs d'une éternelle cause
Le Temps scintille et le Songe est savoir.

On another occasion, a beautifully sunny morning, as we sat watching a sailing-boat make for the shore, he remarked: 'I am

like a ship coming into harbour after a long crossing. My hull is covered with molluscs and barnacles, which I take with me throughout life's journey.'

There was no sadness in his voice. He was coming to terms with facts. Picasso got up, took me by the hand, clasping it very firmly, and drew me towards the gate which led to the homeward path, adding: 'In your company, I have forgotten everything.' Then we walked back in total silence, each pursuing his own train of thought. It was lunchtime and they would be expecting us at l'Escale. Nevertheless, I could not resist asking him one question which had been on my mind for a long while. 'When I was a little girl' – it was our private way of referring to 1944–5 – 'you asked me one day, when I was going into raptures over the bull's hide . . .' Embarrassed, I stopped. With a roguish expression, he took over my uncompleted sentence: '. . . why you didn't stay. I meant it. You don't know how much I wanted you to stay.'

'Then why didn't you say so? I thought you were making fun of me.'

'You were so young; you seemed so pure. I was afraid of scaring you so that you would never come back. Do you remember? I didn't dare get too near you or caress your hair. You don't know how I longed to.' I confessed that in those days I was still inexperienced and might well have run away.

'Do you remember that exhibition on the Boulevard Raspail that I took you to?'

Did I indeed! I remembered especially the amazement of Monsieur Kaganovitch and the people in the gallery when they suddenly saw Picasso in the flesh, Picasso who so rarely went to any such exhibition.

'Do you remember, I wanted to show you one painting – a little girl, naked, holding a basket of flowers?'[57]

Picasso had explained to me that the model was a little flower-girl, who at the start had posed for him in her First Communion dress, before posing in the nude. When we returned from seeing the exhibition he gave me a reproduction of the picture, though I didn't understand why. Now he provided the explanation: 'The first time I saw you in the studio, when you came for your school's

94

broadsheet, I was at once struck by your extraordinary resemblance to this little flower-girl.'

We sat down to lunch, at the end of which a basket of fruit was put on the table. Picasso took some green almonds and said: 'Let's play at *Philippine*.'⁵⁸ This was a new discovery of his – or did I remind him of it? Now it amused him to try to wake up before me and say, '*Bonjour, Philippine!*' Most of the time, he lost. I suspect that he deliberately forgot, in order to have an excuse to give me a lot of useless things such as a laundry iron for travelling. I have no talent for domestic chores, and in any case what could I have ironed except my dungarees? But Pablo was by nature very generous, and because of that it was risky to go walking with him in the streets. You only had to look for a second at something in a shop window and he went in and bought it.

Picasso extended generosity to all those around him. Marcel, the chauffeur, who had been in his employ for thirty years, knew something about it. Yet at the same time, Picasso obliged him to write down in a little notebook the date and the amount whenever he bought petrol for the car.

One day I arrived at the Rue des Grands Augustins to find Marcel sitting there, waiting for Picasso, but with an anxious look on his face. Inès took me aside and explained that Marcel had 'borrowed' the Oldsmobile, without telling Picasso, had gone off to Deauville and had had a serious accident. 'Monsieur will be furious,' she said, 'could you put in a word for Marcel?' I liked Marcel and agreed to try, but while we were talking Marcel went into Picasso's and came out again hanging his head, but saying nothing. Picasso then called me in. His expression was hard as he asked if I knew what had happened. I told him I had heard about it from Inès, but before I could say a word in defence of Marcel, Picasso announced: 'I simply informed him that as I no longer had a car I no longer needed a chauffeur.'

I thought I must have misheard and inquired: 'Can you do without a chauffeur while the car is being repaired?'

'The car is smashed to pieces. It's irreparable. So I don't need a chauffeur.' And that's how Picasso sacked Marcel.

With this experience in mind, I was not surprised when Eluard

95

once said of the difference between his and Picasso's characters: 'I'm very easily aroused and harbour resentment. Picasso is more brutal but also more precipitate. Once we had a great fight – I don't remember what over – and we remained on bad terms for a year. I turned my back on everyone, Picasso, Nusch . . .' Such fits of anger, followed by a reconciliation, were characteristic of Eluard's behaviour, the most famous example being his row with André Breton. But Picasso was not like that. So Marcel was gone for good. After which, Picasso fetched out an old Hispano-Suiza from some garage and turned his son Paul into his chauffeur. Paul, a tall young man, resembled his father facially. He was also good-hearted and of a kind, carefree disposition. He had a passion for motor cars and when I once ran into him at the Simca garage on the Place de Rennes, he immediately began to talk about the respective merits of our two different vehicles. Paul, who has a good nature, remained more or less unmoved by his father's outbursts of fury.

In those days, Paul was living in a hotel on the Rue de Rennes, Picasso in the Rue Gay-Lussac, and Olga Picasso, the mother of Paul, in Boisgeloup, near les Andelys. I arrived one morning at the Rue des Grands Augustins to find Picasso launching a tirade at Paul which ended with: 'Go and have a bath at your mother's, go to your wife's place, go and have a bath where you like, but I forbid you to take my water.' Paul, unable to have a bath in his own hotel, had gone to the Rue Gay-Lussac before his father woke up, run a bath for himself inadvertently taking all the available hot water, and then disappeared. Pablo was furious but had not been able to give vent to his wrath till Paul came back.

Only once did I ever hear Picasso refer to his own death and eventual heirs: 'If I knew how much time remained to me in this life,' he said to me, 'I would send for a truck and give you everything that I treasure. Do you think my heirs are capable of recognizing the real value of things?' This was said one afternoon in the Grands Augustins studio as the sunlight fell on that magnificent table which was covered with objects of all sorts. 'Take this table for example. They don't know what its value is – I've no doubt

on that score. They'll sell everything.' I could not comment on such an unusual and precise allusion to the fate of his worldly possessions. But I felt Picasso, whose attachment to objects was no less physical than to human beings, secretly suffering as he thought about what would happen to them when he was no longer around to look after them.

Shortly after Paul Eluard's death, Picasso himself developed a congestion of the lungs, probably due to his attendance at the funeral. I too was deeply affected at this time by a death in my family, so I took myself off from Paris to the Auvergne, where I remained in complete solitude for several months.

It was late summer before I returned to Paris, and then I settled at Arbonne, on the edge of the forest of Fontainebleau, in a farm backing on to the street and opening out on the other side around a large courtyard. I moved in as autumn arrived and was soon roaming the forest with its many rocks, discovering to my joy little paths, the marks of deer and the lairs of wild boar.

One day I got back from a walk and found a telegram waiting for me: 'Please telephone ODEon 28-44. Picasso.' Thinking that perhaps something untoward had occurred I rushed to the telephone. Sabartès answered and handed the receiver over to Picasso, who wanted to know how far away I was and whether I could come at once. Anxiously I asked him whether he was ill and he replied: 'No, no – come on, hurry up.' This I did, arriving at about midday but having no idea what this urgent call could be about, after several months during which we had merely exchanged letters. It was a beautiful day. Inès opened the door of the Grands Augustins with a charming smile and, catching me by the arm, whispered: 'Françoise has finally left. Monsieur hadn't the courage to telephone you, but I told him to go ahead and do it . . .' At that moment Sabartès appeared and I went on in. A few visitors were waiting, but Picasso rushed over to me, gave me a kiss and, without making any reference to what I had just learned from Inès, began to indulge in witticisms. Contrary to his usual habit, he did not retire with one person at a time. He introduced me to two of his visitors: one, a kindly old woman, was the

97

widow and the other the daughter of his friend the sculptor Manolo. About two o'clock, Inès was as usual able to serve lunch. We were seven or eight at table, and when the others left at the end of the meal, I remained alone with Picasso. He asked me where I was going, and when I told him about Arbonne, he said he would like to go with me and sent instructions to Paul to join us there in the evening. My car was outside. We both got in and drove off. Picasso had still said nothing to me about what had happened and if I had not known already I would no doubt have plied him with questions. But as it was, I waited.

Picasso began with some remark about Inès's comment – 'Mind you don't kill him!' – when she had seen Picasso being driven away by me, because I had only recently got my driving licence. I had always been greatly impressed by Inès's devotion to Picasso. Picasso recounted how he found her: 'She was picking jasmine at Mougins with her sisters. One thing she can't get used to in Paris is having to live behind closed doors. In Mougins, they all live on their doorstep.' I was listening without replying because my whole attention was focused on the road. Eventually, however, after getting up the hill at Juvisy, the road was less congested and I could go faster. It was then that Picasso, taking advantage of the noise made by the engine, as well as by the air whistling through the open window, to hide the emotion in his voice, burst out: 'Françoise, you know, left by train with the children, while I was away in the car.'

I knew that Françoise did not like going by car and that more often than not she took the train to Paris. I knew too what I had been told by Inès. Yet I asked: 'Left? What do you mean?'

'Left for good. It's all over.' Picasso laid a hand on me gently and I had difficulty in not yielding to a desire to take my eyes off the road. I glanced at him rapidly; his face was in profile, but I knew that he was watching for my reaction. The setting sun formed an aura round his head. His hair had begun to curl at the back. Ever since I had told him how much I missed his forelock, Picasso had allowed his hair to grow longer, yet the pate obstinately remained bald and the forelock never reappeared.

I took his hand, grasping it tight, and the rest of our journey

became an alternation of rapid glances and long silences while the engine whirred without my hearing it. Picasso sighed and in a dead tone of voice murmured: 'You don't know how much I loved you.'

Touched to the quick by his use of the past tense I went pale. He noticed and a look of pain crossed his face: 'What's wrong?'

With difficulty I mumbled: 'Don't you love me any more?'

His face lit up: 'But what are you thinking about? I mean that I am feeling remorseful about you. I have never suffered remorse over anybody as you know. I myself should have walked out sooner – to come and find you.'

This cleared the air and we drove on in silence across the plain of Mâcherin into the shimmering forest. At my farmhouse in Arbonne, which had the pretty name of Beaufort, we were greeted by my boxer, Buck, and my cat Bella. Our mood could hardly have been gayer. Buck put Picasso in mind of his own boxer, Yan, about whose fate I had not had the courage to inquire. There was an open hearth in my living-room, and in front of it stood a leather-covered sofa which bore traces of the claws of my two companions. That was where we sat while twilight descended. I lit the lamp and Picasso began to relax with Buck at his feet and the cat jumping around and purring.

Picasso looked at the brass lamp and the red and white check curtains in the living room. Then with a wink and a roguish look, which usually preceded a facetious remark, he came out with: 'Have you ever heard the Chinese proverb "When the lamp is lit, the visitor should leave."?' I smiled and he went on: 'Beware of proverbs! For example, there is a Spanish proverb that says that the early riser will find the watch the traveller lost on the road. My mother used to say that someone had risen earlier still – the traveller who had lost his watch.'

'But that hasn't stopped you making up your own proverbs. Do you remember saying, for example: "Take what precautions you will, but if you go out in society, you will always bring home with you an aroma of fried potatoes."?'

I had no ulterior motive in saying this. I was simply repeating back to him one of those waggish maxims which were engraved

on my memory for life and which, so far as Picasso was concerned, served to express concretely and wittily some idea which he did not want to labour. But Picasso seized on my innocent words as though they concealed an allusion to the situation, nodded his head and remarked glumly: 'You're right. I should never have left the Grands Augustins to go back to Vallauris. I smell of fried potatoes.' Then, without looking at me, he continued abruptly: 'Have you seen my photo in the papers?'

I wished I hadn't. It had made me sad to see Pablo, who had never bothered with fashion or posed for a press photograph, caught playing the fool, wearing various masks and grotesque noses. I nodded affirmatively.

'Do you know why I was doing it? Why I went back to St Tropez? Why I went to bars and cabarets which I loathe? Yet I went every night. I wore masks and put on funny hats to drown my disappointment at not meeting you. I longed to see you there.'

The evening had worn on and we were still talking, when Paul appeared. Picasso suggested going to Barbizon, and sent his son ahead with two girl friends to the restaurant Bas-Bréau, where we arrived a little later. We dined alone together. I thought Picasso seemed both happy and worried. Several times he asked me whether I had changed. I don't think he was satisfied by my answer.

Next morning Picasso told me he intended to have himself driven back to Vallauris by Paul. I was both surprised and hurt, because I thought that he would stay a few days either at Arbonne or at the Rue des Grands Augustins.

Our two cars were parked side by side and everyone had got into the Hispano except Paul, who was waiting to say goodbye to me, and Picasso. The latter, at the last minute, turned round to me and said: 'Are you coming?'

Paul was standing around with a smile on his face, for he had never liked Françoise Gilot. But I don't know what was happening in my head at that moment, except that I was still trying to catch up with the developments of the past few hours. I had been once with Picasso to the villa La Galloise and had not liked it, probably because it was associated first and foremost with a period

in Picasso's life which did not concern me. But no sooner were the words out of my mouth than I began to feel ashamed of the reply I made, and I am still embarrassed today. For my only answer was: 'First of all, change the sheets.'

That very evening, I was taken to task by Dominique Eluard for not having understood how intensely Picasso desired me to become his intimate companion. Looking back now many years later it seems to me that during the months of our separation, Picasso had increasingly come to desire that I would share his life. Yet, when, after the disappearance of Françoise Gilot, the opportunity presented itself, he lacked the courage to tell me so during the day we spent together. He had waited till the last moment, when he was retiring again into solitude, to show his hand. But at that moment I myself, wounded to think that he would leave without me, was in no mood to hear what he said.

During the preceding months, we had exchanged many letters and the idea of a volume of my poems, illustrated with drawings by Picasso, had taken shape. But I was nervous, because I could not believe he meant it when he said that my poems reminded him of Apollinaire. I was suspicious also of the encouragement given to me by Paul Eluard, since he was Picasso's close friend. A mutual friend therefore passed them to Jacques Audiberti, who was so enthusiastic that he sent me by way of a preface a splendid essay on the art of poetry.

When Picasso returned to the Rue des Grands Augustins, we selected my poems together and they appeared in June 1954, under the title *Les Cavaliers d'ombre*, with my name linked to those of Picasso and Audiberti. Picasso liked the volume enough to talk to all his friends about it. Only two hundred copies of the first edition were printed and these were quickly sold out. When I arrived at the studio one day, Picasso was talking to someone who had come there hoping to find a copy, and I was introduced as though it were a joke with the words: 'There's not a copy of the book left, but here is the author.' The man's expression showed that he had not come there for that!

I was not altogether surprised that 'the book', as Picasso called it, was a success with bibliophiles, though I never for a moment

believed that it was due to my poems. I was, however, more than delighted when my royalties from this joint publication brought in enough money to enable me to buy a prize mare called, 'Etoile de la Lyrette'. Picasso then took a special pleasure in reminding me that I must be the only poet who, during his lifetime, had been able to indulge in the superfluous.

Our relationship remained on a plane of affection and tacit collusion. During that summer of 1954, I went to see him in Cannes at the Villa La Californie which had formerly belonged to the Moët family. Apart from the harbour, there was nothing much I liked about Cannes. Least of all this enormous, over-elaborate villa.

At this same time, an Italian publisher approached me, through his representative in France, with the request to contribute a poem to a volume he planned on 'Picasso and his Children', other possible contributors being Jean Cocteau and Jacques Prévert. Flabbergasted though I was at the thought of appearing in such distinguished company, I accepted. Yet even with the backing of Picasso and Audiberti, I had qualms of conscience. What would happen if Cocteau or Prévert should refuse to be associated with someone as unknown as myself? In order to dispel my fears, the publisher's agent offered to take me to meet both of them.

My first meeting was fixed at Santo Sospir, the villa on Cap Ferrat belonging to Madame Weisweiller, where Cocteau was then living. I arrived there, accompanied by my chaperon, with a pounding heart and clasping in my arms, as though it were a testimonial, 'the book', which was of such proportions that I did not know where to put it.

Cocteau gave me a dazzling welcome. And I was soon under the spell of his dream-palace, with a mosaic designed by himself in the entrance hall, paintings by him on the wall of the staircase going down to a large salon overlooking the sea, and faces painted by him on several doors. Cocteau wanted to see 'the book' at once. I expected him to start turning the pages and to come across the seven drawings by Picasso. But not at all. He put on his spectacles and began to read attentively. The silence was broken now and then by a passing boat with an outboard motor, though I felt as

if my own heartbeat might be just as loud. When Cocteau had finished reading, he handed me back the book saying: 'You are a true poet. Most of what I am asked to read nowadays is mere sing-song. But not *your* poems, *you* exist.'

The publisher was delighted as he saw his project coming nearer realization. But I could not believe it. For a long while I was convinced that I was being nicely treated out of respect for Picasso, who was known for shying away from worthless projects. After we had talked a while, I told Cocteau how much I had enjoyed his play *Bacchus*, which I had seen in Paris during the previous winter. Like Picasso, he then disappeared for a while and came back into the room carrying a copy in which he made a drawing and wrote a *dédicace*, to which at that actual moment I attached no great importance. Later on, I learned that I was mistaken. He told me to telephone and come to see him again. So it was in an exalted mood that I drove back to the old hill-town of Cagnes, where I was staying, and despite gas stations, a polluted atmosphere, buildings which shut out a view of the sea, and a forest of telephone poles supporting a tangle of wires, I thought there was something idyllic about the Côte d'Azur.

My publisher, whose euphoria was equal to mine, decided to take me up at once to St Paul de Vence where, after passing the houses of André Verdet and Borsi[59] as we drove round the ramparts, we ended up at the house of Prévert. I already knew by heart many of the poems in his volume *Paroles*, just as I had much enjoyed the films Prévert had made with Carné. But I had left 'the book' behind, thinking that for the moment Cocteau's endorsement would suffice. Prévert, who had no desire to talk with our intermediary for one moment longer than was necessary, dismissed him – the procedure was not as polite as it sounds – and led me away. He talked brilliantly. But as soon as he heard the name of Cocteau, Prévert let out a yell. He would not, for anything in the world, allow his name to appear alongside that of Cocteau, whom he accused of 'fooling people'. To my great astonishment, I then witnessed Prévert's mood go rapidly through every stage from gentle humour to downright mockery and real fury.

Since the middle of the afternoon we had been sitting together

outside La Colombe d'Or, and now evening was approaching. Madame Prévert came down to remind him that they had friends coming to dinner. 'Yes, Yes,' said Prévert, without interrupting his flow of talk, which held me spellbound. Night fell; the head-lights of the cars as they went down the hillside made luminous patterns; the first stars began to twinkle in the deep Provençal sky. As I knew that Prévert had guests for dinner, I became embarrassed and tried more than once, unwillingly, to end the conversation. Jacques, in the most adorable manner eventually insisted on seeing me to my car, while his wife, who was no less embarrassed than I was, came back to tell him that their friends had arrived. 'Yes, Yes,' Jacques replied, and when finally he shut the door of my car it was quite late.

The projected book never saw the light of day, at least not with contributions from the three of us. I did not mind in the least, for I felt that in those three days I had won something far more important – friendship.

I went back to see Cocteau, though I did not venture to tell him that Prévert would not collaborate. I was afraid of the questions he might ask me. However, I very quickly came to realize that so many demands were made on his time that Cocteau welcomed any project that died of its own accord. Jean was incapable of saying 'No', though later he resented not being able to fulfil an obligation to which he was committed. His health was already delicate, hanging on 'a thread of wire' he said with a laugh. He had worn himself out doing the elaborate decorations in Santo Sospir.

I was not at ease with him. He was too elegant, too organized, and even when he gave me a warm welcome I could not help wondering if he really enjoyed my company – of what interest to him could I be after all? – or whether his behaviour was simply a display of beautiful manners. Whenever I was there, he would begin by talking about Marlene Dietrich, who he had seen that very morning, or of the Queen Mother of Belgium, who adored poetry and had just written him a letter which he then showed me. I could think of nothing to say. It was worse than with Picasso nine years earlier, for in the meanwhile I had lost my adolescent self-assurance.

Suddenly Cocteau said: 'I've decided to make you a present. I like your poems and for your second volume I shall do the illustrations.' Somehow I managed to stutter out a clumsy 'Thank you' in my amazement. So it was true, after all, that Cocteau had meant what he originally said. I left him in a daze and went to see Picasso and tell him about all that had happened to me in the past few days. Nothing could have been more distressing than to hear him comment with a sneer: 'Cocteau? He'll promise anything. Just wait and see how long it takes you to get drawings from him.'

All at once my future prospects, apparently so bright a few minutes before, seemed to be extinguished. My dismay was quite apparent and Picasso, irritated by this, began to regret what he had said. Jocularly he added: 'Well, don't worry if Cocteau lets you down. Go on writing poems and I'll make more drawings for you.' I was consoled and went back to Paris at once.

A few days later Cocteau telephoned from Cap Ferrat to announce that I could come down when I liked because the drawings were ready.

I had hinted to Cocteau when I last saw him at Santo Sospir that the poems I had written since the publication of *Les Cavaliers d'ombre* – or at least those I could show for his approval – were not yet enough to make a second collection. 'What does that matter?' Jean had answered. 'You go on writing, and I'll draw at the same time and you will see that the two will fit together perfectly.' A short while after this, I sent Jean the manuscript of *Santo Sospir*, a poem inspired by our meeting. His written answer came back immediately: 'Yes, I am remaining on the Cap and I need you. I, or you, or we have had the luck to get a series of excellent drawings. Do you want them coloured? This would make them more intense I think (I have ten or twelve drawings waiting for you). Yours, Jean.' Then in a PS: 'I have pinned the poem to myself.' Encouraged by this, I sent off to Jean a package of poems, which were eventually published under the title *Sous le manteau de feu*.

At his suggestion, I flew to Nice, where to my delight I found him waiting at the airport. He wanted to show me at once what he had done, and there lying on the floor, just as he had told me,

I saw a pile of blue harlequins and female heads. A grotesque monster, coloured like a sunset, added a dazzling note. 'Take your choice,' said Jean. I hesitated, so he bent down and with his long bony fingers quickly picked up the scattered sheets and handed me twelve drawings. 'That's for you. Take them all.'

Lunch was ready. When we came back to the salon, it was late in the afternoon. By that time the October sun was low and casting long thin shadows across the bay of Villefranche. Cocteau, I thought, suddenly looked tired, so I left him and went back to my hotel on the tip of Cap Ferrat. That night I slept badly, due to my excitement, and it was late next morning when I was woken by the telephone. Jean was downstairs. I dressed in a hurry, he joined me and we walked out onto the terrace. Gardeners were at work planting a tree in the hotel garden. Jean pointed to them excitedly and said: 'Look, they're planting a pepper-tree in honour of our meeting. That will be our tree.'

Some time later, in a letter, Cocteau explained his agitation to me: 'Valéry nicknamed me "the pepper of the earth". Neither pepper nor salt, a sort of talcum powder or grey snow. My only hope lies in the foliage of this tree. I must "enter dreamily" and crush its leaves in my hand.' And the letter ended with these words: 'The pen and ink are still inactive. Your poem consoles me for being infirm.'

The allusion was to something Cocteau had said to me on the terrace at Cap Ferrat, where he spontaneously disclosed his fear of not being able to write any more poetry. This was what he called his 'infirmity'. As he watched the gardeners gradually lifting up the tree from a recumbent position on the lawn, Jean had said to me sadly: 'Poetry is like intelligence: a fatality of birth.' Then turning round, with his back to the garden, he warned me: 'It is more difficult to *live* than to *be*.' But once we were at table his natural gaiety returned.

Though I remember being bemused at the time by all the brilliant things I heard Jean Cocteau say, I confess to my shame that I cannot recall one of them today. I went back to Paris tightly clasping my twelve drawings, and soon afterwards I was telling Picasso of my triumph. But he expressed no wish to see them, and

was mortified by his attitude. What is more, he never missed an opportunity after that of saying something unkind about Cocteau.

Cocteau and I carried on a regular correspondence, and when the bad weather drove him away from Cap Ferrat I used to visit him in his suffocating little apartment in the Palais Royal. Jean had recently discovered the talent of Bernard Buffet and talked about him with enthusiasm. He also took me to see an exhibition of his paintings. After that, however, he took umbrage at being sent a book by Annabel, Buffet's wife, with the bare inscription: *A Cocteau, Annabel.* 'It's like writing *A Balzac, Flaubert.*' Nor could Jean stand Françoise Sagan: 'She ought to write a book. But she doesn't know how, because no one has ever shown the poor darling how to do it.' I did not like Cocteau's social side, so once he had invited me to his house in Milly, I very rarely went back to the Rue de Montpensier.

Cocteau was right, his drawings were in perfect harmony with my poems. He was indeed so pleased with the book that he suggested he should himself transfer his drawings on to the lithographic stone. He also designed a cover, with the result that the book had 'twelve drawings and a cover' rather than thirteen drawings. But Jean was in delicate health, so when I saw him arrive at Mourlot's printing establishment, wrapped up against the cold in his overcoat, and watched the effort he made while working on the stones, I felt sorry for him.

One day I witnessed an extraordinary display of his facility. Mourlot handed Jean a proof of a *Harlequin* with his bat raised, printed on a blue ground. Cocteau took it in his hand and, almost without looking, started to tear around the edge of the paper. When he had finished, the drawing appeared to have an old mirror frame round it. It was transferred back onto the stone, and in the next proof the figure, framed now by a succession of white scrolls, had more elegance than before.

Jean would arrive at Mourlot's punctually and spend the whole morning conscientiously working on proofs until he was satisfied. More than once he had qualms of conscience and wanted to scrap what he saw and do something else. This dismayed the publisher, who saw his book being seriously delayed.

During this same period, Jean was presenting himself for election to the Académie Française, and he had already composed the cover design before he learnt of his success. This meant adding after his name at the last minute – in type instead of in his own handwriting like the rest – the usual mention *de l'Académie Française*. Jean seemed to take a special pleasure in the fact that his first publication as an *Académicien* would be illustrations for the work of a young poet. I was also fortunate in having a foreword written by Armand Lanoux, whom I had met by chance in the television studios. We had both been invited by Pierre Dumayet to appear on his programme *Lectures Pour Tous*, myself to present *Les Cavaliers d'ombre* and Lanoux to present his volume *Colporteurs* which had won the Prix Apollinaire that year. I told him that I had enjoyed reading it. He thanked me, but I saw by his expression that he did not believe me, so I astonished him by beginning to recite from memory one of his poems:

> *Le foulard cramoisi, le veuf, le lait du cou,*
> *au bouquet de la fontaine*
> *la mariée en noir*
> *lonfa maluré dondaine*
> *La fontaine des Innocents*
> *qui pleurait beaucoup*
> *des larmes de sang*
> *lonfa maluré longtemps . . .*[60]

Thus began a long friendship between us which has lasted till this day. For Lanoux has not changed since he became a member of the Académie Goncourt.

Once Picasso had got used to the idea of my book being illustrated by Cocteau he began to take an interest in its make-up. When I showed him the first proofs, his immediate comment was: 'What did I tell you? You see, he's always imitating me.' Picasso handed back the proofs rather crossly. I then showed him some of my recent poems which he began to read more attentively than usual. When he had finished, and before handing them back, he gave me one of those incisive looks which seemed to cut deep into my soul.

'How right I was to tell you to work, and go on working,' he then remarked. 'You are a true poet. Carry on. Soon I'll do a new book with you.' I was overcome and left speechless by a combination of emotion, love and gratitude, with a tinge of remorse for what had occurred that autumn in Barbizon. What could I say? I stared at him and felt like weeping. Picasso took my head in both hands and with deep affection began to stroke my hair. Then I recovered my calm.

Not long after, Picasso left Paris, and the following summer I went to visit him in Cannes as I had promised, to show him 'the book'. He was with Jacqueline Roque when I arrived. She tactfully retired, leaving us alone in the studio of La Californie.

Picasso's first question was whether I had come to Cannes alone, and when I replied in the affirmative, his face brightened. 'I'm glad you can be alone. It is so important.' We chatted somewhat light-heartedly for a while, and rather soon I left. I went to find Jean Cocteau, who took me off to the Music Festival in Menton. I didn't know what to say when he asked me if I had seen Picasso. Jean had too much discretion to ask me outright what Picasso thought about the book and his drawings, though I knew he really longed to be told. But in fact Picasso had said nothing more since his accusation of plagiarism, and I was obviously not going to repeat that.

As autumn crept on I felt, nevertheless, a veil of sadness shrouding my memories of Picasso. During our last meeting, the conversation had lapsed into silences that would never have occurred before. After his initial comments on solitude, we had talked quite superficially. I felt somewhat disillusioned. What is more, I definitely disliked that horrible villa in Cannes. Picasso was far removed now from the poverty that he had so fiercely defended while pacing up and down on the worn floor-tiles of the Rue des Grands Augustins.

I gradually put together a new selection of poems for Picasso to illustrate. He had agreed, in advance, that this second volume

should be less luxurious than the first and would contain two drawings by himself and two gouaches by Cocteau. Jean then decided to add a two-sided cover, so that the section illustrated by himself would appear upside down in relation to the section illustrated by Picasso. And he was soon referring to it as my 'two-headed book'.[61] This volume was to be published in the following spring (1952), while the successor to *Les Cavaliers d'ombre* appear a bit later.[62] No one knew better than I did that Picasso only worked when he had the feel of the thing. No one could impose a time-table on him. In any case, I was in no hurry, as I had all my life ahead of me.

But I miscalculated. The publisher in question,[63] after issuing the volumes illustrated by Picasso and Cocteau, next produced a book with lithographs by Utrillo[64] and then *Les Parisiennes* with lithographs by Jean Gabriel Domergue[65] and a prefatory text by Cécil Saint-Laurent. This put Picasso in a towering rage. Why should he allow his name to appear in any catalogue alongside that of Domergue? 'If that, then why not in the catalogue of the Bon Marché?' he fulminated. So to my great sorrow Picasso there and then refused to go on with our project. And soon after, he left Paris for the shores of the Mediterranean.

It took me at least a year to realize that Milly had begun to take the place of the Rue des Grands Augustins in my life. In both places I enjoyed the unique privilege of living crowded moments with a man of brilliant intellect, who was ready to display his wizardry for me alone. I am thinking now of the Mondays I spent at Milly, for I quickly made it clear to Jean that I did not wish to be invited to his Sunday receptions. I was bored by all the famous men and fashionable ladies who formed his throng of admirers. When they were there, Jean assumed that artificial and elegant personality which I had encountered when we first met. He lived up to his own legend, or to what all those people expected of him. On Sundays, even the crackling of the fire in the vast open hearth was drowned by the chatter which Cocteau himself, with all his

cleverness, could never succeed in raising above the level of banality, except when, as a private distraction, he himself indulged in verbal fireworks. On Mondays, by contrast, the fire again presided, punctuating with its crackle Cocteau's sentences, which evolved clearly while the wind howled and the trees groaned under the rain's onslaught.

Jean's talk was not unlike that of Pablo, in that it was both serious and animated, replete with ideas expressed in very simple terms and characterized by the lack of deference of man who serves a great wine in a pewter jug.

Generally I arrived just before lunch, having walked through the forest which lay between our two houses. My Great Dane, dark brown in colour, usually came with me, because Jean loved animals and was still sad over the death of his own chow-chow, which he had had to leave behind with the caretaker when he went to live at Santo Sospir. 'My dog couldn't bear the separation,' he recounted in a sad voice. 'He ate tufts of his own hair until he died of it. Even animals can commit suicide. I can't describe the guilt I feel for not having taken him down with me.' With a sigh, Jean began to stroke my dog's head and she looked at him with her green eyes.

That year, winter dragged on a long while. One morning at the beginning of March, before going to Milly, I took a short walk in the forest, where a thin layer of snow covered the ground. There were no leaves on the trees, but also no buds, nor were there any of those premonitory swellings which show that the sap is rising and that the new foliage will soon appear. Suddenly my eye was caught by a delicate green shoot underneath the snow. I uncovered it with my hands and found a jonquil in the grip of the cold. It seemed to be pursing its lips over this prank of nature, much as Jean used to purse his lips when he was happy. That is to say, his mouth puckered, while the down-turned corners of his lips twitched with malice. Picasso, on the other hand, used to laugh heartily baring his teeth.

I brushed the snow away from the jonquil with care and picked a small bunch of frozen flowers which I took to Jean. He put them to his nose, but the flowers smelt only of snow and the leaf-humus

III

which had nourished their growth. He was silent and thoughtful, while outside the French windows of the *salon* rain and melting snow had begun to fall. The gnarled and twisted branches of the cherry trees in the orchard showed no signs of the masses of white blossom with which they would be covered in a few weeks' time. Further away still, the trees of the forest were swallowed up in deep shadow. The horizon, almost within reach, was full of foreboding.

Jean inhaled the scent of the flowers deeply, then handed them back to me with a vase as he said: 'I'm going to make a special cocktail for you. I'm very good at making them.'

Jean knew that I never drank hard liquor, nor had I observed him drinking any either. So I had the feeling that he was trying to shake off some private anxiety, whose cause was unknown to me, though it seemed to take hold of him as I presented my symbol of hope on this persistently grey morning. The lamps were lit, the fire was burning cosily and my dog lay in front of it asleep.

The heat of the room was causing little drops of water to form on the petals of the jonquils. Jean handed me a glass, sat down in an armchair and said: 'This morning I had a telephone call from the abominable snowman.' There was silence between us. I did not want to ask Jean what the call had been about, because Picasso was so sparing in his use of this means of communication. Jean took a sip from his glass, and I followed him. But still I said nothing. Then he went on: 'He doesn't come to Paris much any more.'

I looked out of the window, where the morning was unchanged – wet, grey and cold. 'He's right. He's better off in the sunshine.'

This time it was the fire that spoke and my sleeping dog sighed with contentment. I too sighed inwardly under the weight of thoughts that were suddenly as icy as the ground outside. Jean, simulating an air of indifference, then asked: 'How long is it since you last saw him?'

I refused to think back. With all the strength of will I could muster, I directed my mind and thoughts to the fire, to the comforting presence of Cocteau and my dog, to the friendly light of the lamps, to the jonquils which were beginning to lift their heads – to anything at hand which was not connected with the past.

But Jean was insistent: 'You ought to go and see him.' Almost without thinking I replied: 'I don't want to. I don't feel like it.'

'Nor do I,' Jean admitted at once.

We did not realize what we were saying. We exchanged looks of consternation, each of us refusing to recognize the full import of his own words. Jean first had the courage to do so: 'Do you realize what we have just said? It's outrageous! We've just agreed that we don't feel like going to see Picasso.'

There was nothing for it but to sigh or sob my heart out. I closed my eyes and clenched my fists until my nails bit into the palms of my hands. Jean had involuntarily brought me back to the edge of that same precipice over which I had seen Picasso vanish only a few months previously. Into my mind flooded the memory of that last visit to Cannes – already a traditional formality – which had finally frozen my heart in regard to the past, as though a door had been slammed shut.

I arrived before I was expected and therefore had had time to wander in the garden. To my great astonishment I saw sculptures that seemed to need a half-light standing in the full glare of the sun – that unmitigated sunlight of the south of France in August. There forms were so flattened by the harshness of this light that I no longer recognized them and they said nothing to me. Children were running about on the paths. I found my way back to the front door. Picasso and Jacqueline then received me in a vast *salon* which was to all intents and purposes unfurnished, except for a sofa pushed against one wall and some easels. This meant that most of the parquet floor – admittedly it was polished – was exposed and unencumbered. The French windows were open on to the garden and a view of the sea. One saw here and there buildings in course of construction, and I could not help recalling something that Cocteau had said when I was moaning over all the horrors which were replacing the mimosas and oleanders in the coastal landscape: 'A beautiful dog doesn't lose its beauty because it has fleas.'

Conversation had begun slowly. Jacqueline, with the same discretion as before, left the room. Picasso and I exchanged a few

trivial words, but he was embarrassed by the increasingly long silences. Then Yan the boxer came in from the garden, carrying in his mouth a bit of wood which he dropped at my feet.

Had there been any furniture in the room, had I not been highly conscious both of the deep-seated scorn which Picasso had consistently shown for any external sign of riches, and likewise of how he had walked barefoot on the terra-cotta tiles in the Rue des Grands Augustins, throwing down his cigarette butts rather than use an ash-tray, I would certainly never have ventured to pick up the toy which this poor animal had dropped at my feet and throwing it across the parquet floor. Yan ran after it, barking with delight. So when I then heard Picasso saying to me: 'This is no place to play with a dog,' I thought I was dreaming.

At that moment he died to me and I began to bury the Picasso I had known deep in my heart and my memory. Thereafter, I was able, without suffering, to watch some quite different man – although he had the same face – appear in public and act out many a grim charade. For me, however, the real man had ceased to exist, having dug his own grave long before his time. I stayed a few minutes longer, then left, carrying away as my sole comfort the sombre glow of his eyes, hardened once more by despair. I decided, there and then, never to see this other Picasso again.

The fire died down. My dog opened its eyes in surprise, and the clock of the near-by church chimed midday.

'Strange things happen in life!' It was Jean's voice. 'There are times when one is dead without being so. For example, as I lay unconscious in the hospital I asked for paper and wrote page after page. That was *Requiem*.[67] And do you know that when I came out of my sort of coma, I couldn't even read what I had written? I had to send for someone who was accustomed to reading my writing. And even then, there are still words which I have never been able to make out.'

Over the crackle of the fire, which was coming back to life, over the beating of the rain against the window-panes, over the noises of

the wind, his voice echoed round me through the room: '. . . times when one is dead without being so . . . times when one is dead . . .'

With a cry of 'Pablo!' I buried my head in my hands. Never again, Pablo . . . never again.

Even if, after our last meeting in Cannes, one flicker of hope had still remained within me, it had been irrevocably extinguished by what had been said by Jean and myself. It was finished once and for all. The Pablo I had loved, the man who had given me so much, was gradually fading from view as he passed over to the other bank, from which there is no return – that steep and treacherous slope of the past.

In Jean's house, with its black moat and Pablo's shadow hovering around, I felt the weight of Orpheus' grief on my shoulders.

Yet chance was to bring us face to face once more, at the Auberge des Maures in St Tropez. I went there with the man to whom I was briefly married, as well as my dog, to meet some friends. They got to the restaurant first and on our arrival indicated three people sitting at the next table, saying they were with Picasso who had gone to wash his hands.

At that moment, Picasso walked back into the room. He saw me, his eyes lit up and I felt that I had found him again. He hurried towards me, whilst I responded to the same impulse. He kissed me with great affection. Then he admired my dog. After that, I introduced my husband, who had risen from the table. With a laugh, Picasso murmured: 'He's a fine fellow, *hein!*' and congratulated him 'on having married beauty and the beast'. Then Picasso went back to join his own guests. He did not take his eyes off me for the rest of the meal, while my mind was flooded with memories of the near-by Rue des Bouchonniers, to which I had never returned.

Then I remembered a story Pablo had once told me: 'I had a friend whose name was Bloch. He came out first in the violin class at the Conservatoire. One day I was invited to the 'Meurisse',[68] where he played in the orchestra. I was unable to eat. I was con-

tinually getting up to stand by him and talk. But in between I had to go back to my meal. And I felt very sorry on his account. He was delighted on the other hand that I was there and that he could play for me. All of which proves that one should neither feel sorry for nor envy others.'

After that my mind rolled back, still with a sense of intense pain, to that morning in Barbizon when our paths had finally diverged. And then, over the babble of voices around me, I seemed to hear Pablo's voice, though its tone was muffled, saying as he had long ago: 'One must always let events take care of decisions . . . People often grow weary.'

When he had finished eating, Picasso got up slowly from his table and came over to me. He threw his arms around me and kissed me without saying a word, looked at me intensely, sighed and walked out. I never saw him again.

Mais celui qui porte en lui son âme,
Non pas comme une vache pleine qui rumine sur ses quatre pieds,
Mais comme une jument vierge, la bouche embrasée du sel qu'elle a
* pris dans la main de son maître,*
Comment saurait-il la serrer et la contraindre, la grande chose terrible
* qui se dresse et qui crie, dans l'étroite écurie de sa volonté*
* personnelle,*
Alors que par les fentes de la porte avec le vent de l'aube arrive
* l'odeur de l'herbage?*

<div align="right">

La Ville
Paul Claudel*[69]

</div>

* But the man who carries his soul within him,
 Not like a pregnant cow on four feet, chewing the cud,
 But like a virgin mare, whose mouth is afire with the salt that it has taken out
 of the hand of its master,
 What chance would he have to enclose and restrain that great and terrible thing
 which ramps and screams within the narrow stable of his personal will,
 When the odours of the meadows are wafted by the wind at dawn through
 the cracks in the door?
 (translated by Douglas Cooper)

October is ending. The leaden sky weighs on the shoulders of the forest. The captive light reflected from the ground catches the trembling foliage. Suddenly the sun breaks through the clouds. Silence lies heavy around us, my horse stops and pricks up his ears. There is a crackling of dry leaves, then the air is rent by a screech as a large crow flies off. A hunting-horn can be heard in the distance: fear of this has driven the animals into their shady lairs.

It feels as though death, my strange companion of the past weeks, has come amongst us. It may strike Pablo down in his 92nd year.[70] It will come at dawn for the stag whose belling has disturbed the calm of the full moon, and for the fuddled old boar in his muddy lair on the edge of some fairy dewpond.

It may come to extinguish in me that spark of life which has been dwindling unnoticed, as one morning's awakening has followed inexorably on another – most of them forgotten, a few preserved thanks to that marvellous faculty called memory. For it is memory, which leaps from a branch to a face, from a twig to a moonbeam, from a stone to some scribble on a sheet of paper, that has given back to me in such profusion my awareness of words, of gestures, of voices, of facial expressions.

Only by a hair's breadth has it spared me – time being on my side – the ordeal of re-living the pangs of sorrow and the no less enduring joys as though they were dead leaves burning in a brazier.

This autumn I have traversed, at one bound, hell and heaven. And I now discover that my remorse, tucked away as I thought in the darkest depths of oblivion, has been purged. Henceforth peace reigns in my soul.

Like the season, I myself can wither and die.

<div align="right">Les Baux – July 1972
Marlotte – 27 October 1972.</div>

Notes

1 A dilapidated wooden building, containing a complex of studios, which was perched on the edge of the Montmartre hillside. So-called because externally it resembled a 'laundry-boat' on the Seine. The name was given to it by Max Jacob. Picasso lived there from 1904 till 1909. Among other inhabitants were van Dongen, Juan Gris, Manolo, Pierre Reverdy and André Salmon.

2 An ink drawing dated 4/3/1955; Zervos, Vol. XVI, No. 367.

3 Picasso met his future wife, Olga Koklova, while he and Cocteau were together in Rome in March–April 1917, during the creation of the ballet *Parade*. The story about the train is a characteristic affabulation by Cocteau.

4 Front National Etudiant (National Student Front).

5 At the time of Stalin's death in 1953.

6 For the poster of the Peace Conference in Paris, April 1949.

7 A college for girls in the Rue de l'Eperon, near the Rue des Grands Augustins.

8 Pierre Reverdy, *Le Chant des morts* (Paris 1948), illustrated with 125 designs in red lithographic ink by Pablo Picasso.

9 Javier Vilato, son of Picasso's sister Lola.

10 R. M. Rilke, *Werke in Drei Bänden* (Frankfurt 1966), Vol. II, p. 341, excerpts from poem No. III of the sequence *Les Fenêtres*. Written in 1924–6, first published in 1927.

11 One of the stories in *Lettres de mon moulin* by A. Daudet.

12 A play on words in French is involved: *peignez-moi* if from the verb *peindre* means 'paint me', or from the verb *peigner* means 'comb me'.

13 The New York art dealer Sam Kootz in 1947.

14 Molière, *L'Ecole des Femmes*, Act II, Scene 5.

15 Charles Dullin (1885–1949) a famous French actor–manager, who ran the Théâtre de l'Atelier from 1920 on.

16 Another actor. Picasso painted a portrait of his wife Gaby in 1904; Zervos, Vol. I, No. 215.

17 Henri-Georges Adam (1904–69).

18 A living French writer, actor and cinematographer.

19 A French poet (1900–1945).

20 A cabaret.

21 A Spanish restaurant in the Rue des Grands Augustins much frequented by Picasso and his friends in the 1940s.

22 Now Mrs Jonas Salk; her children by Picasso are Claude (b. 1947) and Paloma (b. 1949).

23 Nevertheless, when Jacqueline Hutin-Roque joined Picasso's household in 1953–4 – they were married in 1961 – she was accompanied by a young daughter by her previous husband.

24 F. Olivier, *Picasso et ses amis* (Paris 1933); English edition *Picasso and His Friends* (Heinemann, 1964).

25 A small town in the Pyrénées Orientales, near Perpignan. The Catalan sculptor Manolo lived there. Céret became a favourite centre for artists before 1914. Picasso stayed there in 1911, 1912, and 1913.

26 G. Bloch, *Catalogue de l'œuvre gravé de Picasso*, 3 vols (Bern, 1967–73), Vol. I, Nos 613, 614, *Venus and Cupid* of May 1949.

27 Berthe Weill ran a small gallery on the Rue Victor-Massé in Montmartre, where Picasso had four exhibitions in April, June and November 1902, and October 1904. In 1902, Picasso lived in the Rue Gabrielle, higher up the Montmartre hill, *vide* B. Weill, *Pan! Dans l'œil* (Paris, 1933).

28 Sharing a room with Max Jacob. This occurred in December, shortly before Picasso left Paris for Barcelona.

29 A series of bucolic-classical paintings and drawings made at Antibes (the classical name was Antipolis). Many are now in the museum there.

30 *Vide* Zervos, Vol. XIV, No. 40.

31 Pseudonym for Lev Tarassov (b. Moscow 1911), now Membre de l'Académie Française. *L'Araigne* (*The Spider*) was published in 1938.

32 A play written by Picasso in January 1941.

33 A disastrous visit in November 1950 which lasted only four days. A frightened Labour government, then in power in England, distrusted the Peace Congress (held in Sheffield) as a dangerous Communist-run propaganda affair – war had just been declared in Korea – and turned most of the foreign delegates back at Dover. Picasso, on account of his fame, was allowed to proceed to London and arrived by train. Marcel travelled alone with the Oldsmobile on the Dieppe–Newhaven ferry.

34 A novel written (1923) by Raymond Radiguet.

35 See *The Collected Works of St John of the Cross*, translated by Keiran Kavanaugh, O.C.D. and Otilio Rodriguez, O.C.D. (London 1966). St John of the Cross (1542–1591) was a Spanish mystical theologian and poet – a Carmelite friar who, with St Teresa of Avila, was responsible for founding the reformed, or 'discalced', convents and monasteries of the Order. St John's poems were all written after 1577.

36 A French television personality.

37 A well-known cabaret.

38 September 1951. Chabannes is a French television personality.

39 A French actor–manager.

40 Gaston Palewski, later a Gaullist minister and ambassador.

41 An aquatint of 1949, *vide* Bloch, *op. cit.*, Vol. II, No. 1835. Picasso was presumably re-working the plate, of which very few proofs were pulled.

42 Picasso rented a villa at Fontainebleau from May till October 1921.

43 Maurice Thorez (1900–64), Secretary-General and President of the French Communist Party.

44 Helena Rubinstein was persistent and ultimately successful. Picasso made two series of drawings of her: *vide* Zervos, Vol. XVI, Nos 405–416, dated 15 and 16 August 1955; also *idem* Nos 504–522, dated 27 November 1955.

45 The friendship between Pierre Reverdy (1889–1960), a well-known French

poet, and Picasso developed around 1909; later Reverdy was to become a close friend of Braque and Gris.

46 The matador Luis Miguel Dominguin, who became a close friend of Picasso after 1950.

47 14 June 1951.

48 Frédéric Mistral (1830–1914) was the most famous Provençal poet.

49 Literal meaning 'Seize the day'; from Horace, *Odes* I.

50 20 copies of the first edition, published by Editions de Minuit in 1944, had contained an etching by Picasso; *vide* Bloch, *op. cit.*, Vol. I, No. 296.

51 Geneviève Laporte, *Les Cavaliers d'ombre*, Preface by J. Audiberti, with 7 reproductions after drawings by Picasso (Paris 1954); *Sous le manteau de feu*, Preface by A. Lanoux, with 13 original lithographs by Cocteau (Paris 1955). These two collections of poems (with 7 additional ones) were published in one volume in 1956 (the *livre à deux têtes*). See Note 61.

52 A popular restaurant on the Seine, near Bougival, with boating and bathing facilities, which was kept by Père Fournaise in the 1860s and 1870s. Monet and Renoir painted there in 1869.

53 *Vide* F. Mourlot, *Picasso lithographe* (Monte Carlo, 1950 etc.), Vol. II, No. 109, pp. 49–63; this proof was of 29 May 1949.

54 Mourlot, *op. cit.*, Vol. II, No. 144, of January 1949.

55 P. Eluard, *Le Visage de la paix* (Paris, 1951), with one original lithograph by Picasso; *vide* Bloch, *op. cit.*, Vol. I, No. 687.

56 P. Valéry, *Le Cimetière marin* ('The Seaside Cemetery'), written in 1920, published in the volume *Charmes*.

57 *Girl with a Basket of Flowers* (1905), Zervos, *op. cit.*, Vol. I, No. 256; then in coll. G. Stein, now coll. David Rockefeller.

58 A fresh almond with twin nuts. The game is for two people to take one each and agree that, when they next meet, whoever says '*Bonjour, Philippine*' first will get a present from the other.

59 André Verdet, a Communist writer; Borsi, a local painter.

60 *Colporteurs* means 'street-sellers' or 'balladists'. The poems are pastiche folk-lore and untranslatable.

61 This volume contained both *Sous le manteau de feu* and *Les Cavaliers d'ombre*, with some later poems.

62 This volume was to have been called *Le Soleil ebloui*; it is unpublished.

63 Joseph Foret.

64 Entitled *Paris capital*.

65 Published in December 1955; 50 drawings of *midinettes* and the like.

66 Pseudonym for Jacques Laurent, a journalist, editor of *Arts* and author of the film *Caroline Chérie*.

67 A long poem published in 1962.

68 Picasso's way of pronouncing the Hôtel Meurice.

69 First published in 1890; second version in 1897; definitive version in the volume *L'Arbre* (Paris, 1901).

70 In fact Picasso died in his 92nd year, on 8 April 1973, six months after the text of this book was completed.

Index

Abbreviation used: P for Picasso